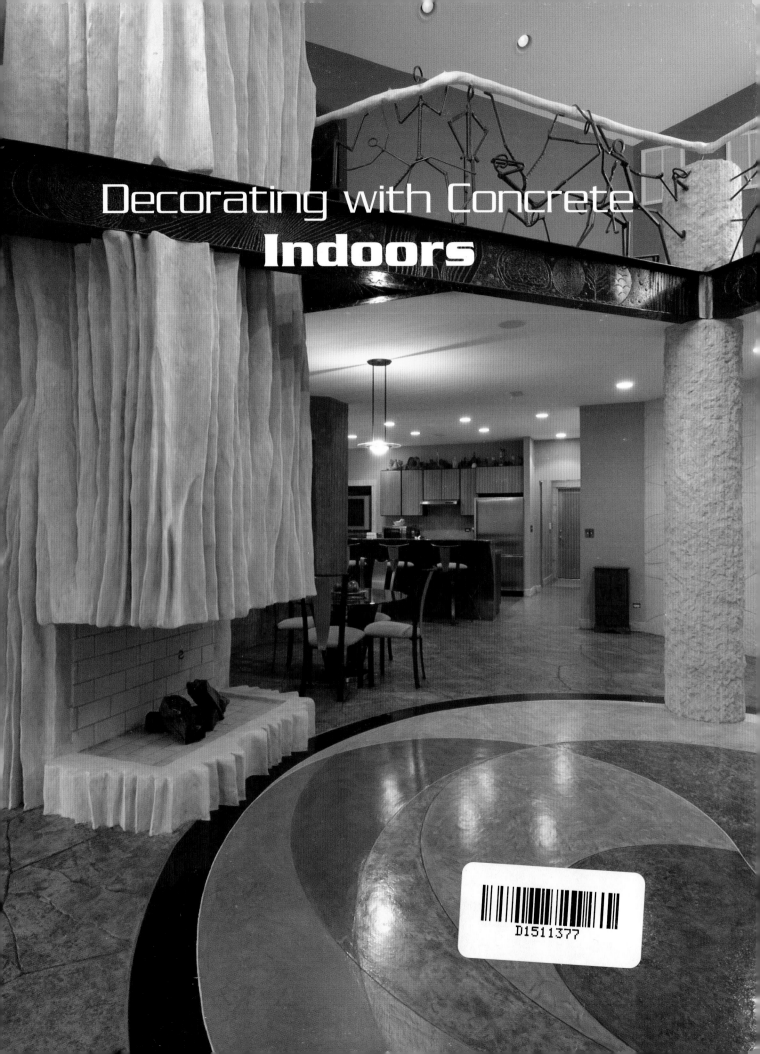

# Decorating with Concrete
## Indoors

# Decorating with Concrete
# Indoors
## Fireplaces, Floors, Countertops, & More

**Tina Skinner**
**The Concrete Network**

Schiffer
Publishing Ltd

4880 Lower Valley Road, Atglen, PA 19310 USA

Library of Congress Cataloging-in-Publication Data:

Skinner, Tina.
    Decorating with concrete indoors : fireplaces, floors, countertops, &
more / By Tina Skinner, The Concrete Network.
        p. cm.
    ISBN 0-7643-2200-1 (pbk.)
1.  Concrete in interior decoration. 1. Concrete Network. II. Title.

NK2115.5.C65S58 2005
747—dc22
                        2004029869

Designed by John P. Cheek
Cover design by Bruce Waters
Type set in Stone Sans/Humanist 521 BT

ISBN: 0-7643-2200-1
Printed in China

**Photo Credits:**
Cover image courtesy of Bomanite Corp.

Inset images:
**Top:** *Courtesy of Courtesy of Action Concrete Services;* **Middle:** *Courtesy of Buddy Rhodes Studio, Inc.;* **Bottom:** *Courtesy of FormWorks*

Title Page: A thin, vertical application of concrete decorated and col-
ored in curving lines and different textures is vaguely reminiscent of
ocean currents. The whole house has become a virtual showroom for
concrete's versatility and beauty. *Courtesy of Bomanite Corp.*

Published by Schiffer Publishing Ltd.
4880 Lower Valley Road
Atglen, PA 19310
Phone: (610) 593-1777; Fax: (610) 593-2002
E-mail: Info@schifferbooks.com

For the largest selection of fine reference books on this and
related subjects, please visit our web site at
**www.schifferbooks.com**
We are always looking for people to write books on new and
related subjects. If you have an idea for a book please contact
us at the above address.

This book may be purchased from the publisher.
Include $3.95 for shipping.
Please try your bookstore first.
You may write for a free catalog.

In Europe, Schiffer books are distributed by
Bushwood Books
6 Marksbury Ave.
Kew Gardens
Surrey TW9 4JF England
Phone: 44 (0) 20 8392-8585; Fax: 44 (0) 20 8392-9876
E-mail: info@bushwoodbooks.co.uk
Free postage in the U.K., Europe; air mail at cost.

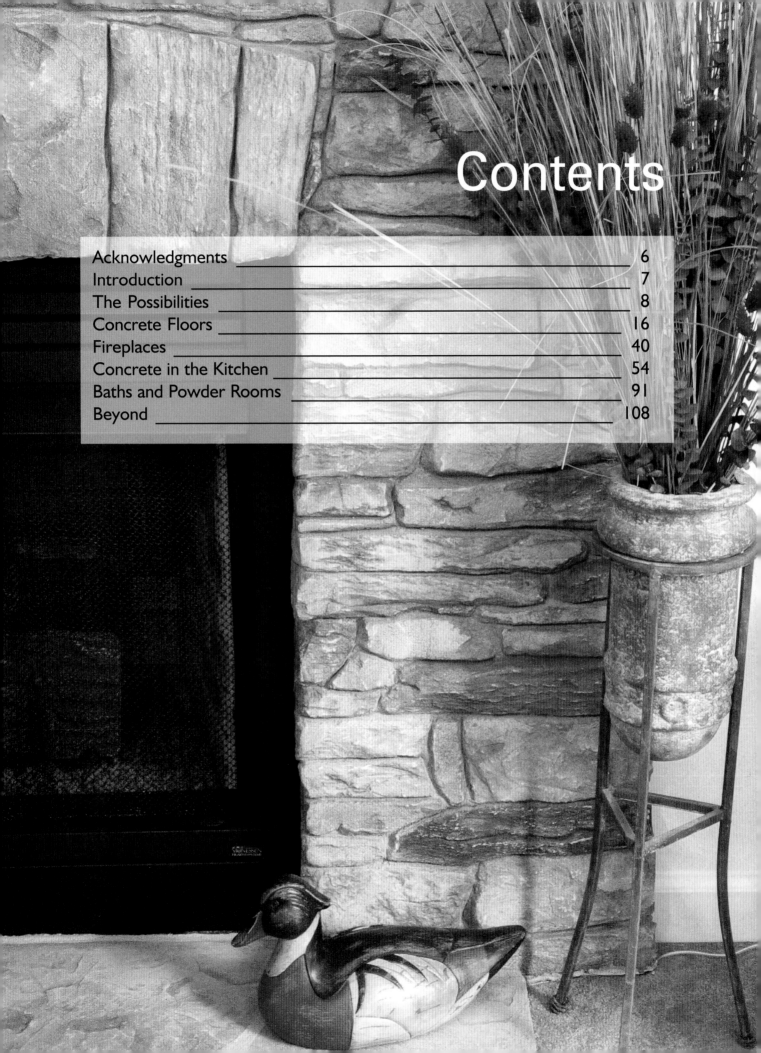

# Contents

# Acknowledgments

The momentum for this book was made possible by The Concrete Network. Streamlined by the quick decision-making ability of founder Jim Peterson, and aided by the efficient staff, including Khara Betz, we quickly contacted all the members of this amazing website to find the talent for this publication. To those who contributed, special thanks for your amazing submissions, and kudos for your craft. It was this pride in craftsmanship and technology that inspired this publication in the first place. Also, thanks to Nathaniel Wolfgang-Price and Ginny Parfitt, who helped sort images and create captions. Also, many thanks to Michelle Carpentier, Lisa Thomas, and Matthew Gregorchuk, who helped illuminate the works herein with their artful eyes and lenses. These photographers are always in search of new commissions. Please consider them:

Michelle Carpentier, The Photography Shoppe
South Richfield, Minnesota
612-869-0691
www.photographyshoppe.com

Lisa Thomas
San Mateo, California
650-222-4338
lisamtms@sbcglobal.net

Matthew Gregorchuk Photography
The440@hotmail.com
805-667-2254

In addition to presenting featured projects within the book, works by the following companies was used as background material throughout this book: Artscapes, Bomanite Corp., Buddy Rhodes Studio, Inc., *The Concrete Colorist*, Concrete Creations, DCI, Kemiko Concrete Stains, and Yoder & Sons LLC.

Special effects shown below were provided courtesy of The Concrete Colorist. To your art, and that of the other contributors, kudos and many thanks.

# Introduction

The design possibilities with concrete are virtually endless! Concrete has shed its image of a cold, gray slab, and has now hit the mainstream with decorative possibilities for the indoors!

It has become the new material of choice for a variety of folks, including artists, designers, homeowners, architects, and builders. Whether it is acid-stained, colored, painted, or simulated to look like wood, marble, granite, or other types of stone, concrete is personalizing retail stores, offices, restaurants, and homes everywhere.

One reason for concrete's appeal is its ability to customize.

For interior floors, concrete slabs can become luxurious elements, creating stunning, multi-hued color variations complementing any architecture and décor. Concrete surfaces can not only be colored or stained to match any hue, but the texture is also completely customizable. Whether you're interested in finishes that resemble tile, slate, marble, or brick, concrete can be transformed for a polished, modern look to a time-worn floor that looks perfectly aged.

For countertops, concrete can be molded into any shape, custom-tinted to match an existing color scheme, and can be personalized with embellishments such as stone, seashells, artifacts, personal mementos, trivets and stainless steel heat racks. Concrete can also incorporate other functional features such as integral sinks, drain boards, and butcher blocks.

Another attraction to concrete is that it requires minimal maintenance. Interior concrete floors generally involve periodic dusting or damp mopping.

Concrete is also economical, comparing favorably in price to wood flooring and ceramic or quarry tile.

Concrete is a distinct alternative to other indoor applications. Many people feel confined by the harsh limitations of design or color in limestone, marble, or granite. Concrete opens up to the color palette and can give warmth and color depth not available in other types of products.

Creating a custom look for the interior of a home or office is exciting! Bringing concrete indoors is a versatile way to incorporate your design ideas. You can choose the colors, textures, and shapes that interest you, as well as incorporate your unique ideas for functionality, features, and furnishings.

Concrete has found its place indoors through the variety of possibilities and design options it offers. You, too, can create a one-of-a-kind atmosphere by incorporating concrete indoors and utilizing its flexibility in design.

Jim Peterson
President and Founder
The Concrete Network

# The Possibilities

Concrete's irresistible appeal can be attributed to four things: it's versatility, its look of distinction, its natural qualities, and the display of superior craftsmanship.

## Versatility

Few materials are as versatile as concrete. You can mold concrete into any shape, color it to match virtually any hue, and you can make it smooth or rough. Its versatility lends to a range of design styles, from contemporary to classic.

## Distinctive Looks

Concrete's creative possibilities are endless. Each concrete artisan approaches his or her craft personally, achieving a distinct look by building their own forms, developing special casting techniques, and using proprietary materials and coloring methods. Because each piece is usually made to order, customers can be part of the creative process.

## Natural Appeal

While products like Corian® are popular, many opt for concrete because the look is more natural. For some people, concrete has more tactile appeal than granite, marble, or ceramic tile.

## Superior Craftsmanship

Most concrete artisans are passionate about their work and take great pains to achieve superior results.

## Explore the Rainbow

This book will walk you through different applications for your home, from the foyer floor, to the living room fireplace, and on through the kitchen, bath, and beyond. But before we set out to explore the house, let's visit the potential of concrete with a smorgasbord of samples created by various craftsmen. Again, just a tiny sampling of what's possible.

One of the many benefits of concrete is the wide range of colors and hues available. Is it cobalt blue you're after? Maybe a spicy pumpkin or deep eggplant, an earthy terrazzo or rich jet black? Concrete contractors each offer their own unique standard and premium colors. Samples will always be different because each contractor has his or her own secret recipe for constructing the countertops and employing different types and amounts of cement and aggregates. In fact, cement varies in different parts of the country. There are different brands of pigments, stains, and aggregate colors, so concrete countertops will always be unique.

Color matching is in no way an exact science. Samples of custom colors or requests for matching a particular color will always be more expensive than samples of standard colors. In most cases, the price of samples is applied against the cost of the order. Contractors usually charge $25-50 for standard color samples, $75-$150 for custom colors.

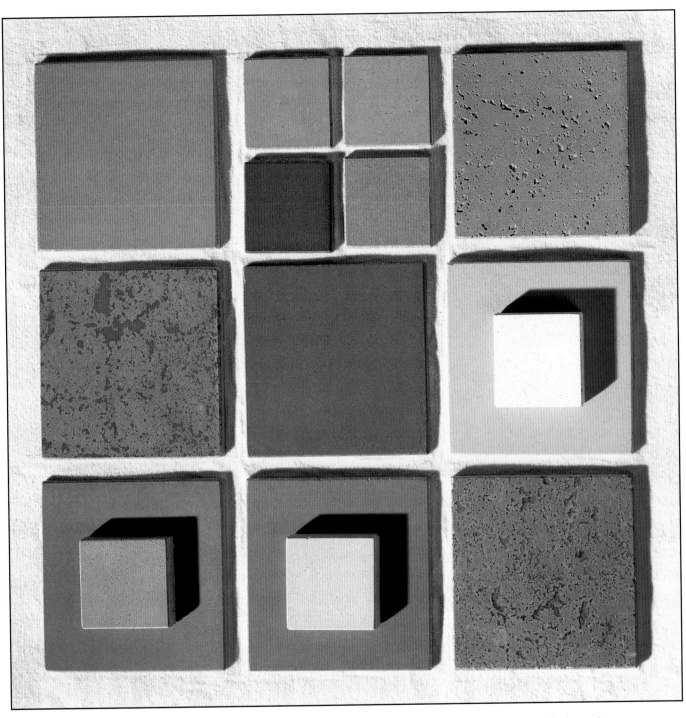

▲Monochrome™, Voidz™, and Terratone™ finishes are illustrated on a sample board.
*Courtesy of Meld USA, Inc.*

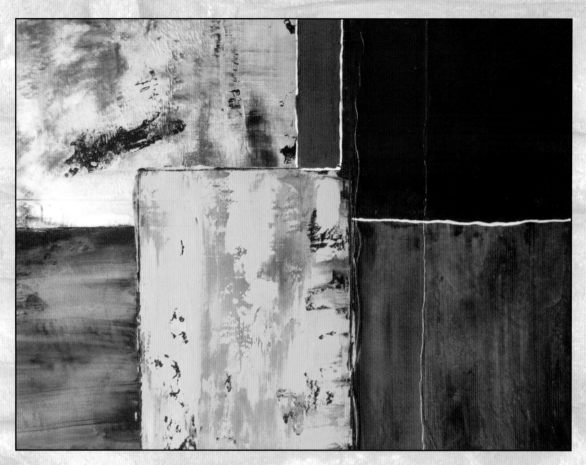

▲ *Courtesy of The Concrete Colorist*

▲ Stencils allow perfect transitions between colors and textures.
*Courtesy of Skookum Floors, USA*

▲ *Courtesy of The Concrete Colorist*

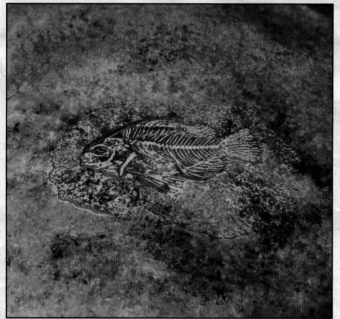

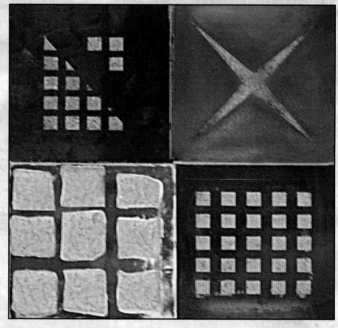

▲Stains mix for animal-skin effect. *Courtesy of Artscapes*

◀Laser cut metal squares of varying sizes and shapes were pressed into concrete to create a rough, weathered, diverse look for these unique tiles. *Courtesy of Sonoma Cast Stone*

▶A fossil-like imprint was created for this countertop. *Courtesy of Concrete Concepts Inc.*

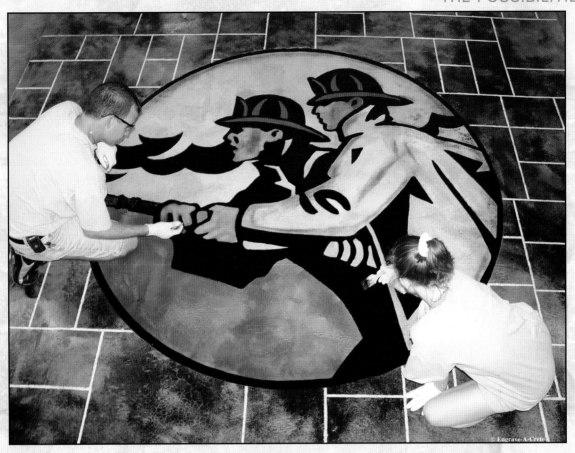

▲ Craftspeople add the finishing touches to a staining project. *Courtesy of Engrave-A-Crete*™

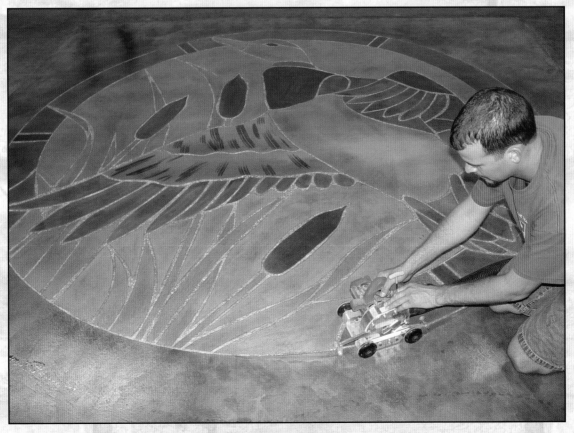

▲ An engraving saw is used to cut a circle around this pattern. *Courtesy of Engrave-A-Crete*™

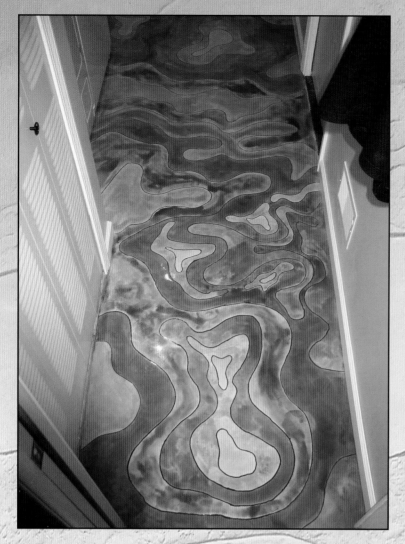

A random swirling pattern was scored into the floor of a utility room. The areas created were hand stained, and the scored areas grouted to create this funky effect. *Courtesy of Courtesy of Action Concrete Services*

Scott Bye, owner of Action Concrete Services, put his personal artistry to the test for various clients, creating wall art on a very thin layer of modified cement. All the lines of the "paintings" were hand engraved and/or etched to create a three dimensional surface. The colors were created with acid stains, colloidal dyes, and water-based stains. They are all privately commissioned, and measure from 30 to 48 square inches. *Courtesy of Courtesy of Action Concrete Services*

▲A stencil allowed the outline of a buck to remain after textured colors were sprayed around it. Two further stencils were used to add highlight colors to the image. *Courtesy of DCI*

◄In this colorful piece of sidewalk art, a geisha has been forever etched in acid stains. The original image was used with permission from *Oriental Stained Glass Pattern Book* by Richard Ott. *Courtesy of Images in Concrete*

# Concrete Floors

Concrete has become the new material of choice for designers and homeowners across the United States. Concrete floors — in stained, colored, painted, and personalized glory — are popping up in retail stores, trendy restaurants, offices, and homes everywhere.

One of the most common places you'll see decorative concrete these days is under your feet. Whether it's acid-stained, painted, overlays, micro-toppings, radiant floors, or a unique personal floor, concrete floors offer a range unlike any other material.

The technology is constantly changing, along with the creative innovations being developed by installers. Today virtually any surface, from Spanish tiles to Oriental carpets can be mimicked in concrete.

Many are welcoming, embracing, and anxiously pursuing concrete floors for their own home projects. All it typically takes is one look — whether in a magazine, on a home tour, a television show, or in someone's home — and you're hooked.

Barbara Sargent of Kemiko Concrete Floor Stains offers a host of reasons why concrete is a popular material for floors:

* It enhances the integrity of architects' designs.

* Concrete floors are easy to maintain.

* It's easy to change, especially if you sell your home. The next owner can easily place carpet or wood on top of the concrete slab.

* Concrete floors are great in regions with a lot of sand or snow.

* Concrete is a healthy alternative to carpet for allergy sufferers.

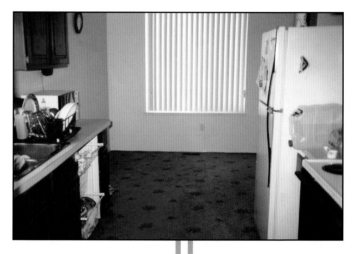

▲Before

▲After

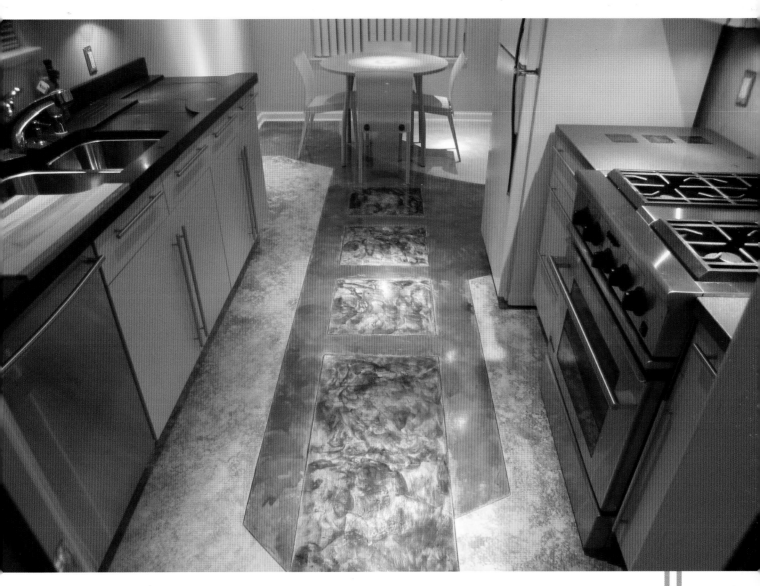

▲These images illustrate a dramatic transformation from plain floor to instant artwork. A thin veneer of concrete was treated to give this kitchen its ultra-contemporary feel, with the dramatic use of acid etching. The deep colors achieved by this process added depth and dimension. *Courtesy of Courtesy of Action Concrete Services* thin veneer of concrete was treated to give this kitchen its ultra-contemporary feel, with the dramatic use of acid etching. The deep colors achieved by this process added depth and dimension. *Courtesy of Courtesy of Action Concrete Services*

# Tile Style >

▶A popular octagonal tile pattern is recreated in concrete. *Courtesy of Sonoma Cast Stone*

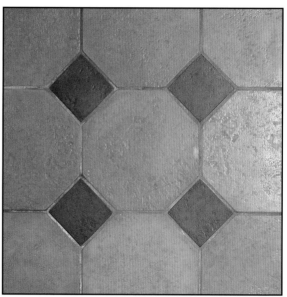

◀Concrete was cast into a two-inch tile pattern. *Courtesy of Sonoma Cast Stone .*

▶These "tiles" were cast into a pattern that creates the illusion that they were woven together. *Courtesy of Sonoma Cast Stone*

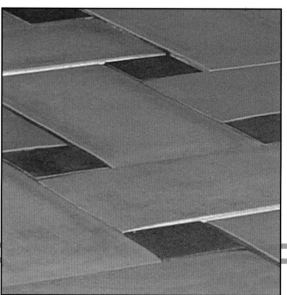

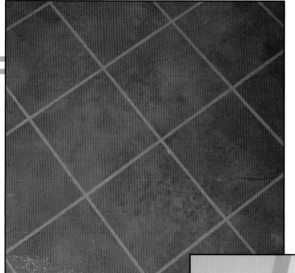

◀Concrete can be textured and tinted to precisely mimic tile. *Courtesy of Specialty Concrete Designs*

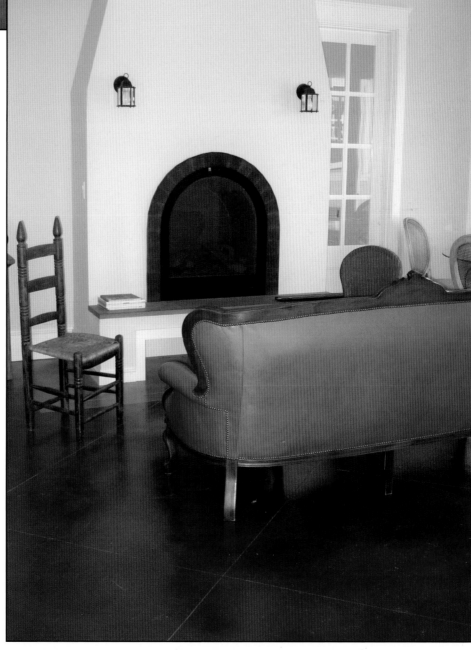

▶Concrete was used to create the effect of oversized tile for this space. *Courtesy of The Concrete Colorist*

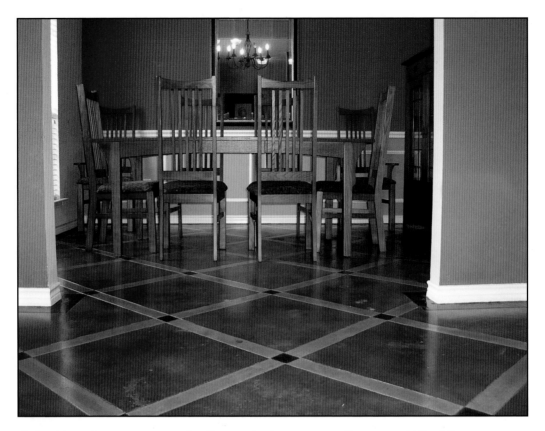

▲A ribbon pattern graces the floor of a dining area. *Courtesy of The Ultimate Edge, Inc.*

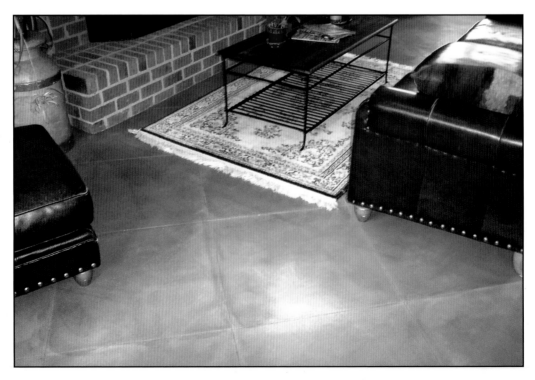

▲A stained and etched floor takes on the appearance of terracotta tile in this living room. *Courtesy of Classic Concrete Design*

Concrete tiles form a surface that is safe to walk on, durable to place furniture on, and easy to clean and maintain. *Courtesy of Bomanite Corp.*

"Woven" concrete tiles give this floor its handcrafted look. *Courtesy of Sonoma Cast Stone*

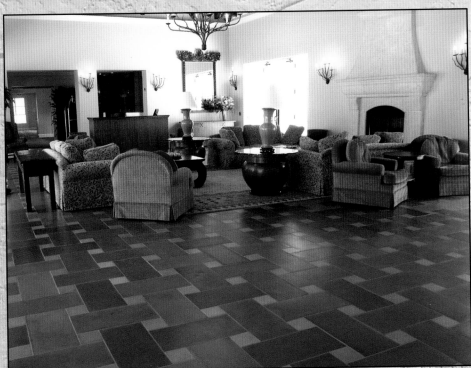

# Cut Stone ▷

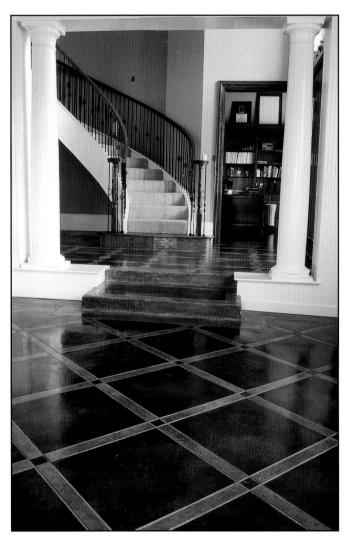

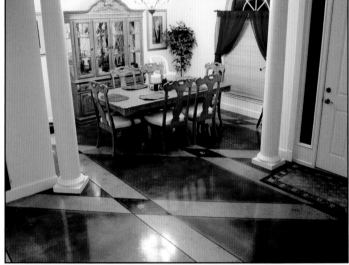

◀A diamond pattern like this is often used on concrete flooring.

*Courtesy of Kemiko Concrete Stains*

▲Etching and staining were used here to create a harlequin pattern.

*Courtesy of Engrave-A-Crete™*

▼Scoring and stains were used to create a diamond pattern.

*Courtesy of Accu Flow Floors*

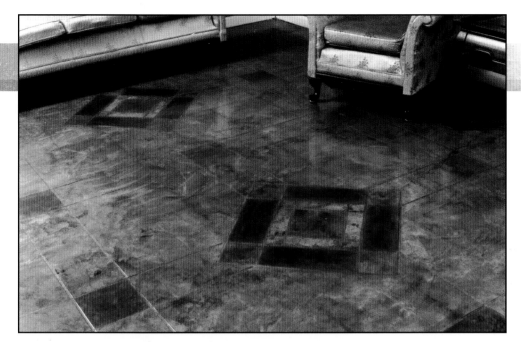

◀ Pigments create different shades of color. *Courtesy of Engrave-A-Crete™*

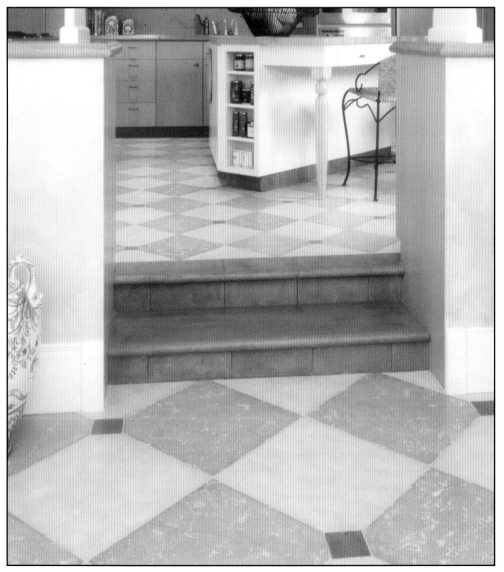

◀ A dark gray set of stairs help to separate two rooms with the same diamond patterned floor. The stripes of contrasting color make the steps more visible and therefore less likely to be tripped over. *Courtesy of Buddy Rhodes Studio, Inc.*

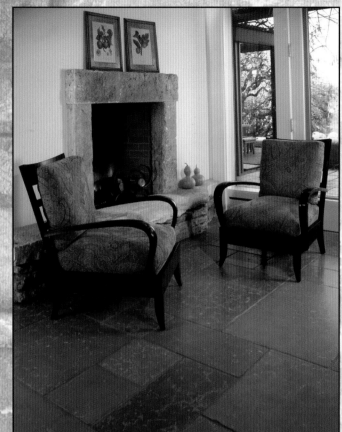

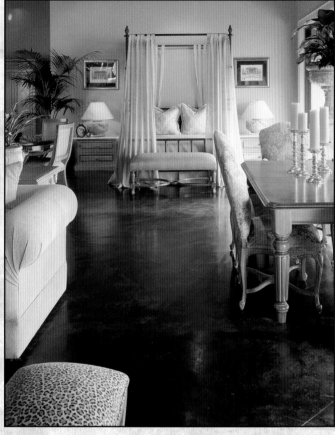

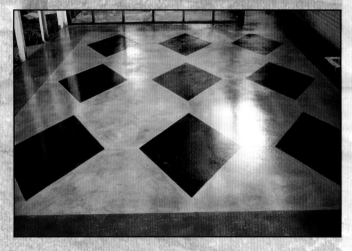

Concrete flooring imitates random size flagstones that interlock to form a pleasing puzzle. *Courtesy of Buddy Rhodes Studio, Inc.*

Multiple colors were used to create this checkerboard design. To maintain the gleam, the homeowners can reseal it annually, if needed. *Courtesy of Creative Concrete Staining & Scoring, LLC*

Lines cut into the surface of this floor create the appearance of overlapping tiles. *Courtesy of Kemiko Concrete Stains*

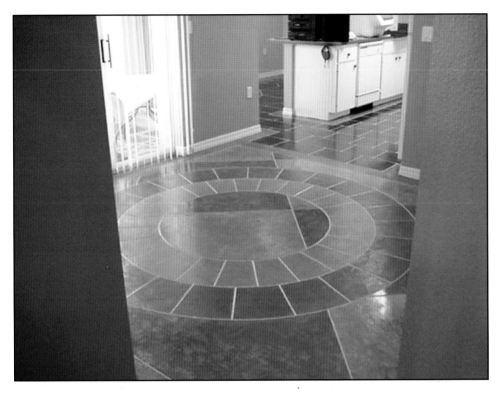

An elaborate stencil creates a filigreed pattern on a front porch. *Courtesy of Creative Concrete Staining & Scoring, LLC*

Intertwined circles denote the dining area, while the kitchen floor beyond was stained to mimic flagstone. *Courtesy of Engrave-A-Crete™*

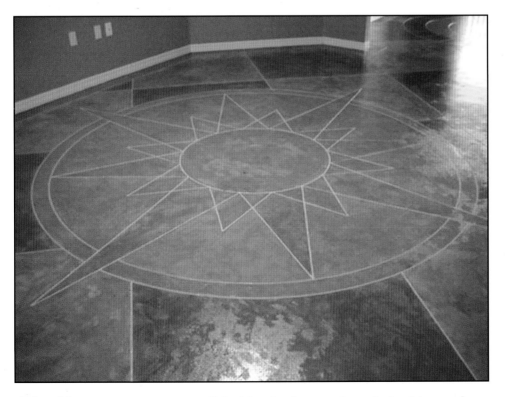

A golden compass rose on a light blue background reminds visitors of a rising sun. *Courtesy of Engrave-A-Crete™*

A sunburst pattern was stained in concrete. *Courtesy of The Concrete Colorist*

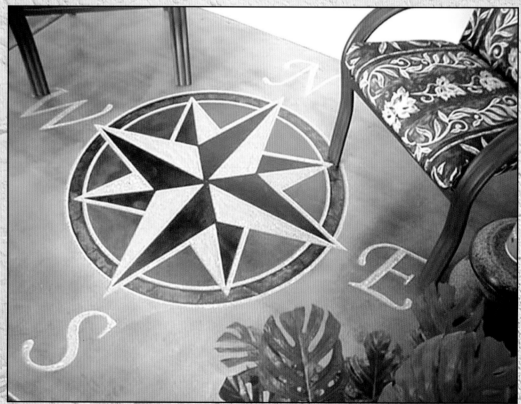

A compass rose makes an interesting decoration for this sitting room. *Courtesy of Engrave-A-Crete™*

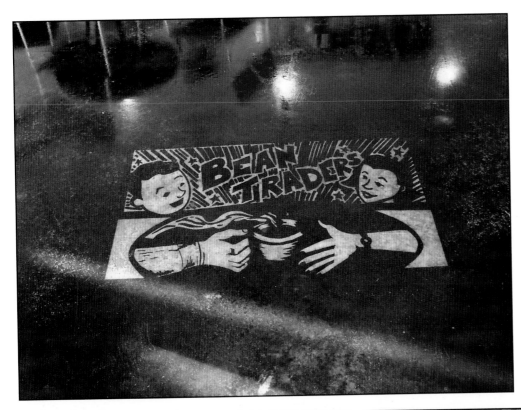

◀A coffee-shop logo was etched directly into the floor, forming a great welcome mat that never needs to be replaced. *Courtesy of Classic Concrete Design*

▼This effect was created using a custom stencil over a standard European fan pattern stencil. The color hardener used for the name was also scattered throughout the surface area to color key the project. *Courtesy of DCI*

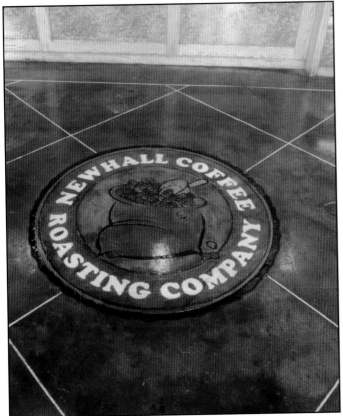

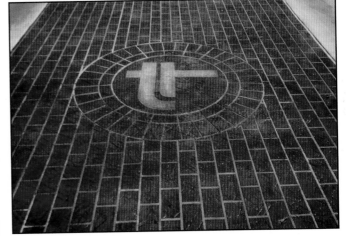

▲This logo has been etched into an already existing floor. *Courtesy of Engrave-A-Crete™*

▲A custom stencil was used to leave a company logo untouched while red color hardener was sprinkled across this stenciled walkway. *Courtesy of DCI*

# Exploring the Color Palette>

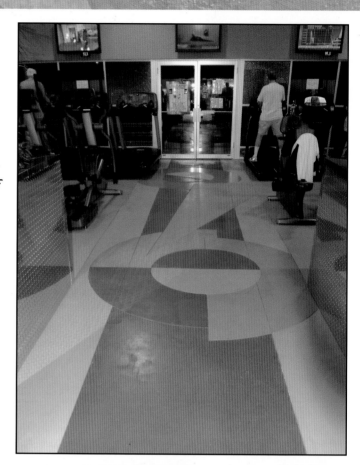

▶Color and design add energy to a gymnasium atmosphere. *Courtesy of Concrete Concepts Inc.*

▼A floor stands out in a memorably colorful café. *Courtesy of Skookum Floors, USA*

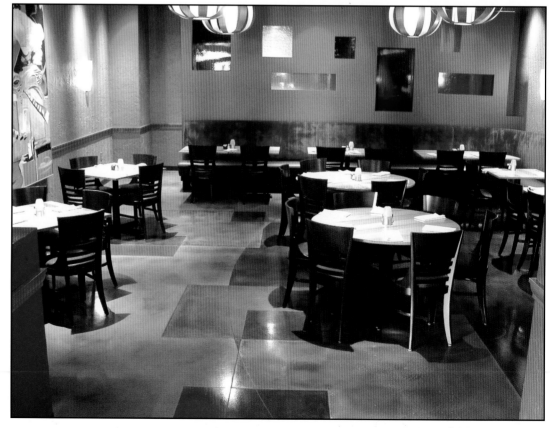

◄A square defines the center of a space, with radiant colors filling the floor. *Courtesy of Artscapes*

▶Here, each separate "stone slab" has been stained a different color and then treated to look like polished stone. *Courtesy of Engrave-A-Crete™*

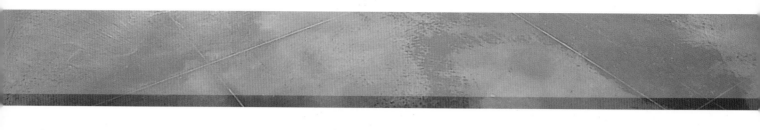

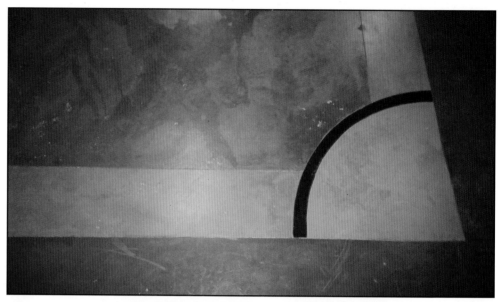

▶A palette of colors was wended throughout a contemporary structure, defining walkways and gathering areas. *Courtesy of Artscapes*

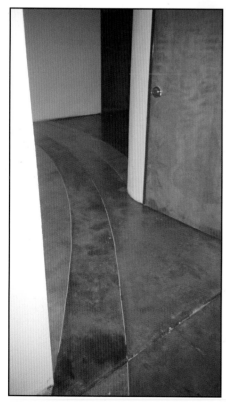

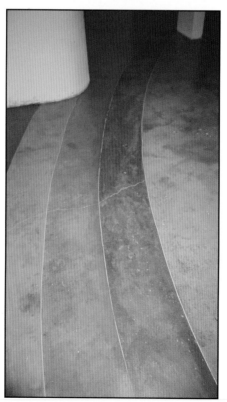

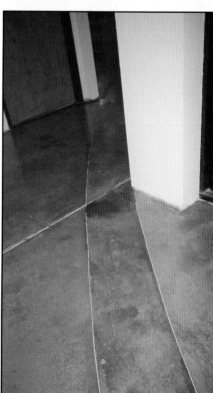

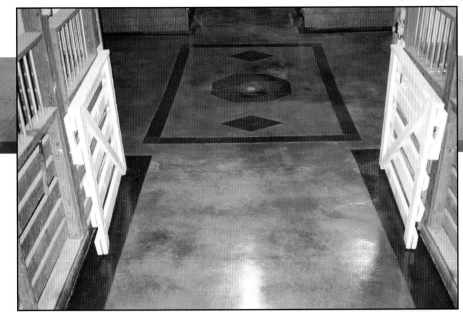

▲A scored and stained design marks the intersection of two hallways in a renovated barn and decorates a drain there. *Courtesy of Creative Concrete Staining & Scoring, LLC*

▶Thin-set concrete is easy to install and can be used to overlay any number of surfaces. *Courtesy of Bomanite Corp.*

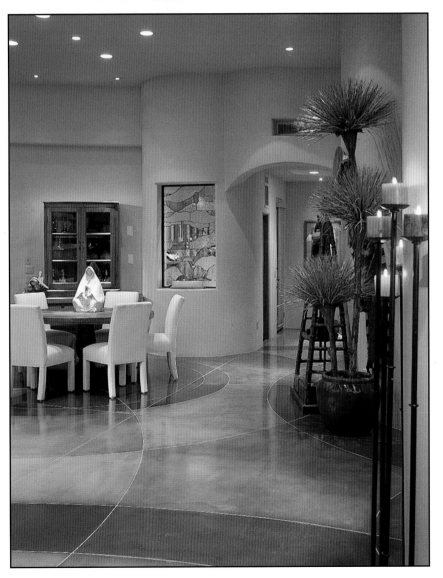

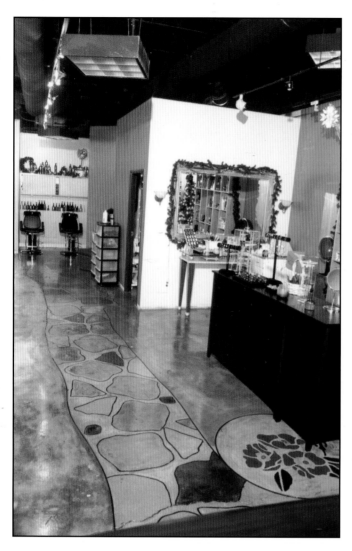

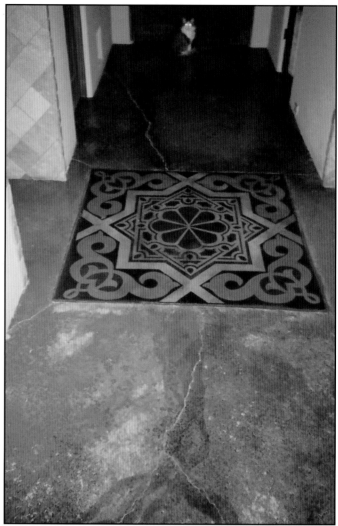

Here, a faux stone path has been stained into the floor to guide visitors to the back of the room. *Courtesy of Engrave-A-Crete™*

A medallion marks the intersection of two hallways. The design is profiled into the concrete surface using acid gels over a stencil; then it is stained, making the effect permanent. *Courtesy of Artscapes*

A central floor area has been staked out within a decorative scroll pattern. Inside, one mottled color becomes the living room "rug." Outside the border, another faux finish in complementary warm tones is extended to the walls. A wax finish creates the low gloss sheen. *Courtesy of Images in Concrete*

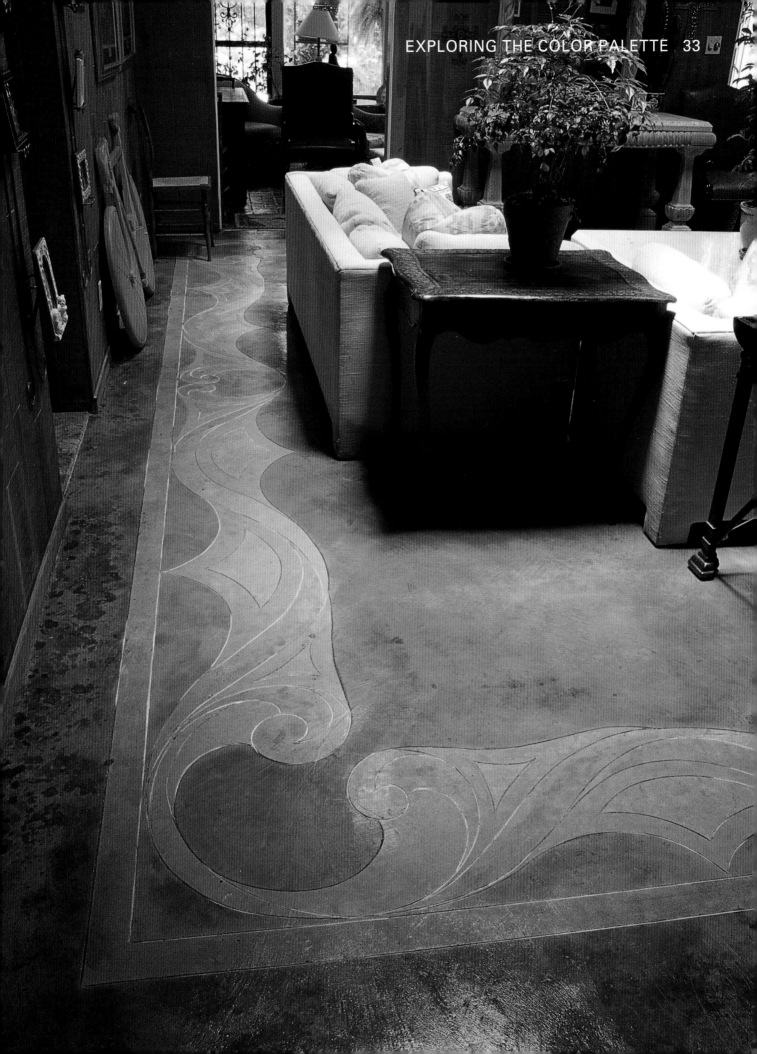

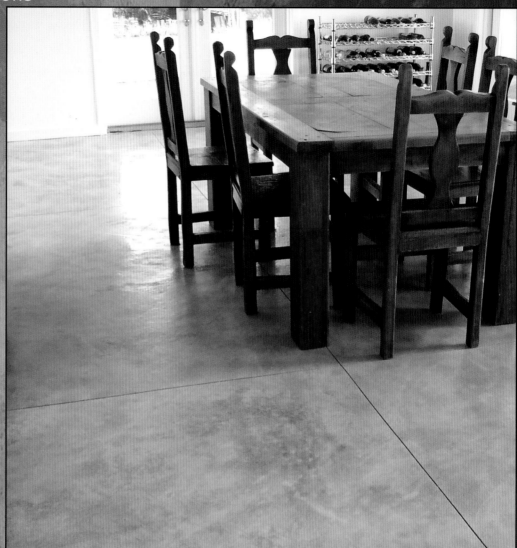

▶A concrete dining room floor is impervious to chair leg scuffs, and simple to clean. *Courtesy of Classic Concrete Design*

▲Abstract fish school in a floor medallion. *Courtesy of Artscapes*

▶Concrete is often used to mimic the appearance of polished stone. *Courtesy of Accu Flow Floors*

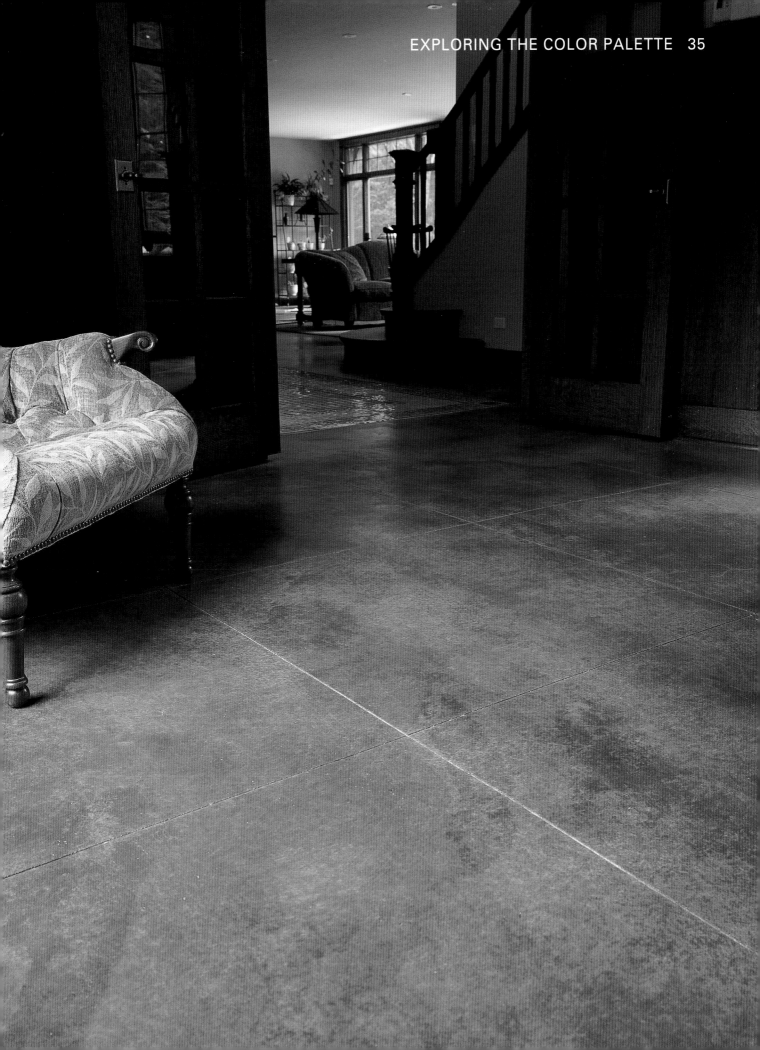

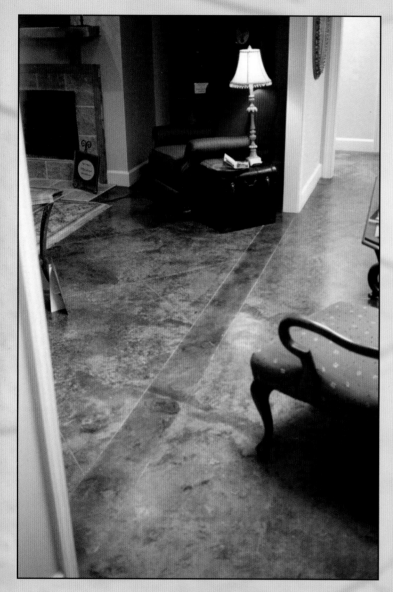
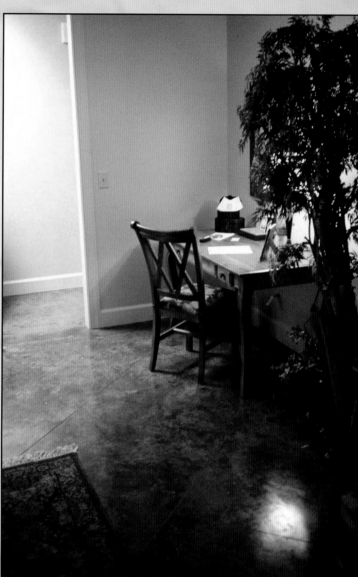

▲Scored and stained concrete can transform an ordinary concrete slab into a luxurious floor, resembling marble, tile, or glazed stone. It works well in any room of the home. Decorative concrete provides a very clean living environment. It does not harbor dirt, mold, or odors, making it a perfect solution for persons with allergies or living with pets. *Courtesy of Creative Concrete Staining & Scoring, LLC*

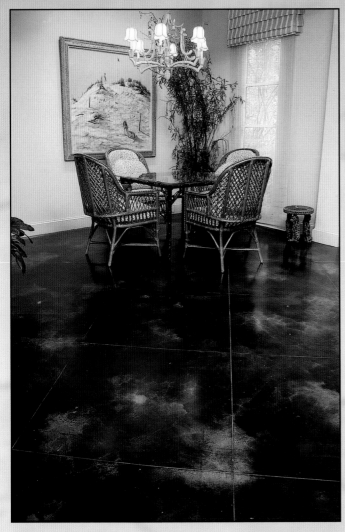

▲ The effect of a crack was created using stains. *Courtesy of Creative Concrete Staining & Scoring, LLC*

◄ The dark marbled finish on this floor warms the large room. *Courtesy of Kemiko Concrete Stains*

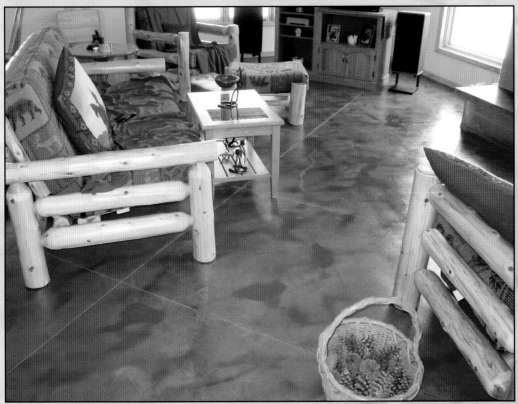

◄ This rustic space is warmed by the terracotta colors of the highly polished floor. *Courtesy of Verlennich Masonry & Concrete*

Staining and a manmade crack create an atmosphere of antiquity. This process entails applying acid stain wet-on-wet, to create a more natural "stone" look. *Courtesy of Artscapes*

The aged brick in a basket weave pattern gives an Old World feel to the space. As opposed to brick, a stenciled pattern provides less relief, and thus is friendlier to foot traffic and scooting chair legs. *Courtesy of DCI*

Golden hues soften the sunlight that floods through these large picture windows. *Courtesy of Accu Flow Floors*

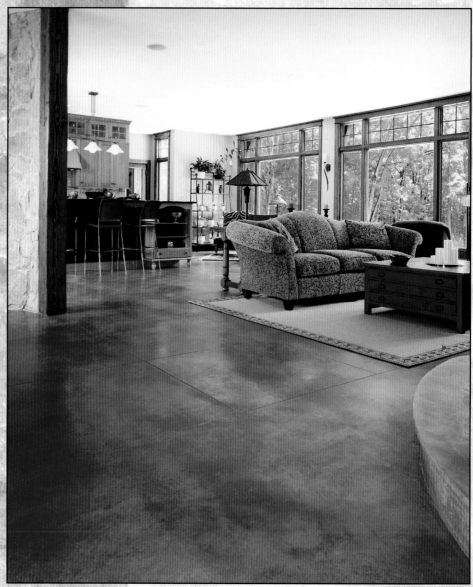

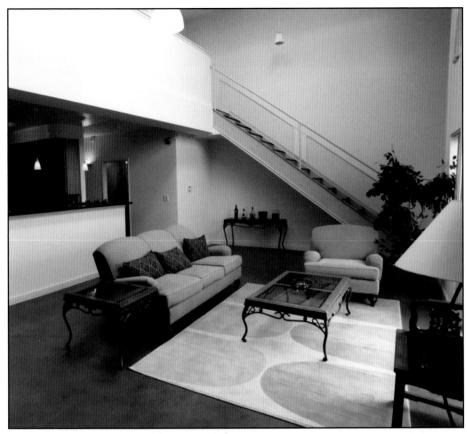

◀A rich brown hue on the concrete floor grounds this lofty space. The effect was created using a one-eighth inch thick overlay of cementitious concrete that was troweled and stained to the desired surface. *Courtesy of The Concrete Colorist*

▼Wall-to-wall concrete creates a wonderful surface for living, easily complimented by natural-hued furnishings. *Courtesy of The Concrete Colorist*

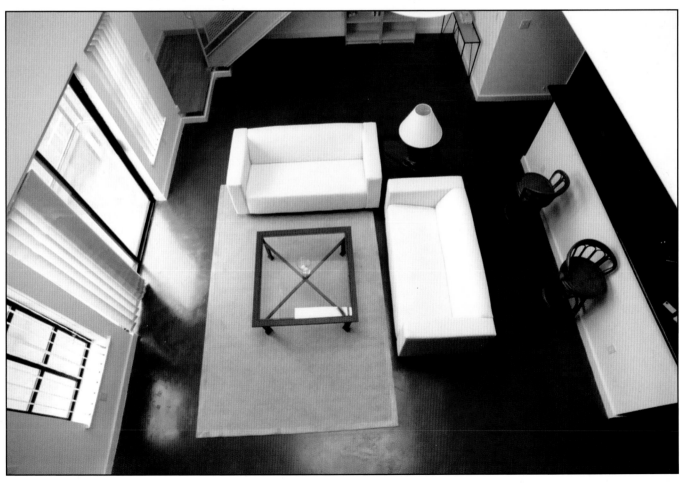

# The Fireplace

Beautiful fireplace mantels can be cast in a shop, and offer tremendous benefits to hand carving. For starters, the use of rubber moulds is more exact than carving and the lead-time is reduced significantly. Also, concrete allows for a wider variety of colors and possibilities, as one is not limited to the size and expense of massive chunks of stone.

Because it is fireproof, concrete can be used for all or several of the fireplace surround components – the hearth, which sits on the floor, the mantel, which surrounds the fireplace, the mantel shelf, and the over-mantel, which can be placed above the mantel shelf to add visual interest.

The fireplace and fireplace surround serve as the centerpiece of a room, both visually and socially. Family and guests inevitably gravitate to this soothing, flickering backdrop for conversation and mingling.

A beautiful fireplace and fireplace surround provides an eye-catching focal point. If properly designed, the fireplace and fireplace surround can serve as a worthy substitute for any work of art.

▲ Since concrete is practically fireproof, it makes a sensible choice for a fireplace surround. *Courtesy of Sonoma Cast Stone*

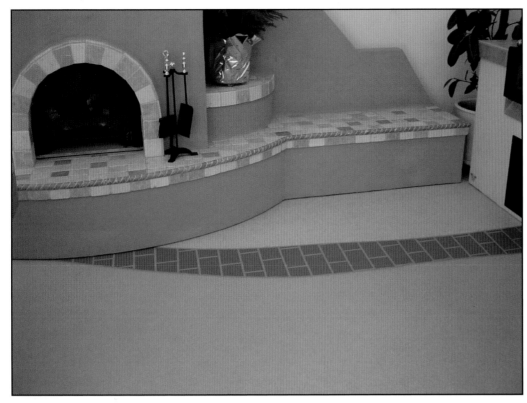

◀Various colors and faux textures were used to make this indoor environment. *Courtesy of XcelDeck™*

▼A solid cast fireplace surround was created with colored concrete to mimic stone blocks. *Courtesy of Sonoma Cast Stone*

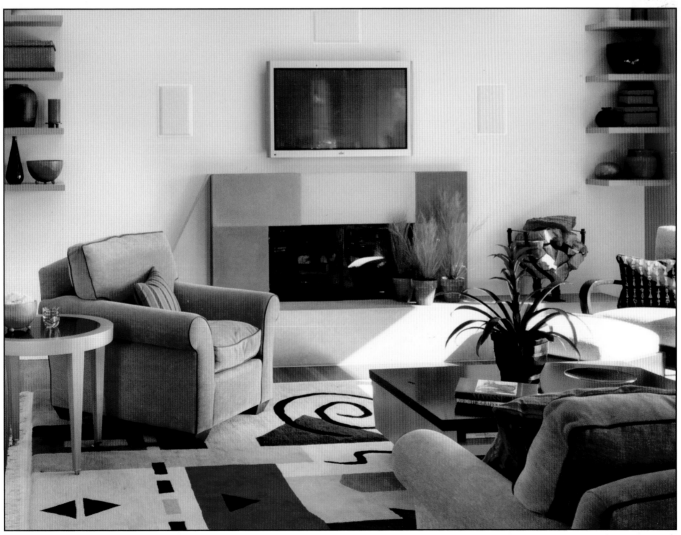

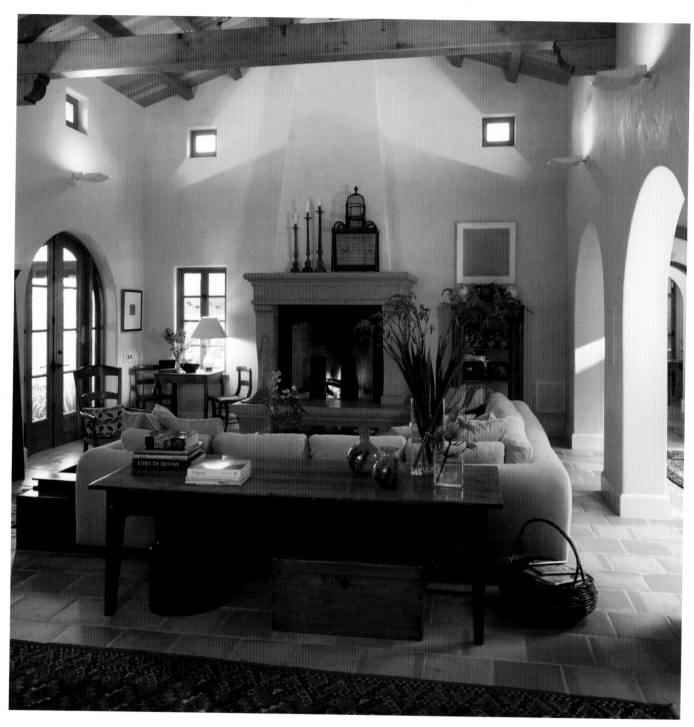

▲In a stately, soaring space, a fireplace is an important, grounding element.
*Courtesy of Sonoma Cast Stone*

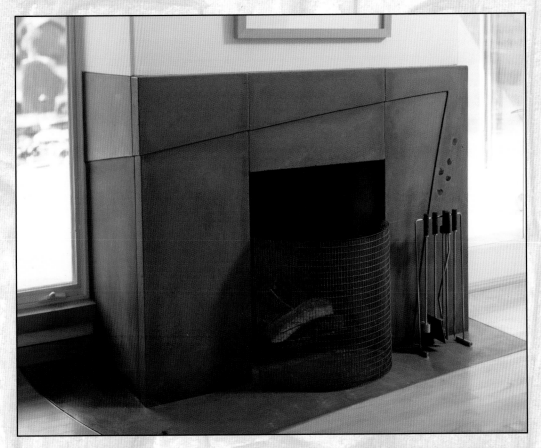

Concrete facings cut at different angles give an interesting, modern look to a fireplace surround. *Courtesy of Sonoma Cast Stone*

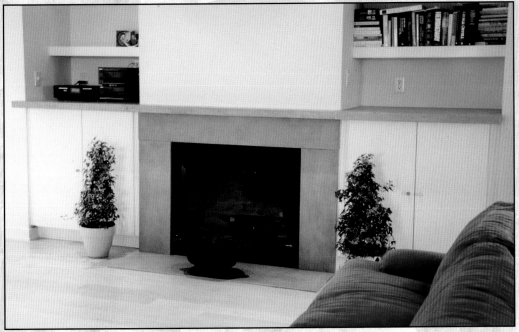

Cantilevered bookcase countertops merge with a mantel that spans 12 feet. Matching hearth and surround complete this clean, contemporary fireplace. *Courtesy of FormWorks*

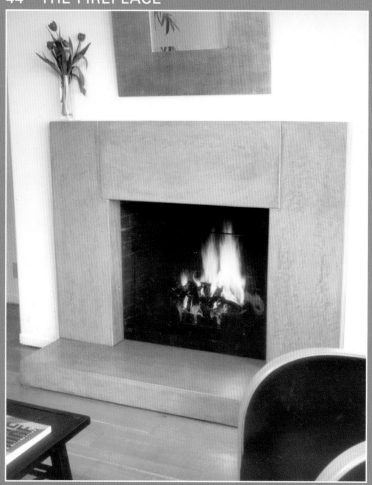

◀Concrete possesses a great deal of versatility when it comes to ornamentation. It can be highly decorative or straightforward and simple, like this fire surround. *Courtesy of Buddy Rhodes Studio, Inc.*

▶This fireplace surround acts as a picture frame for the fire. *Courtesy of Buddy Rhodes Studio, Inc.*

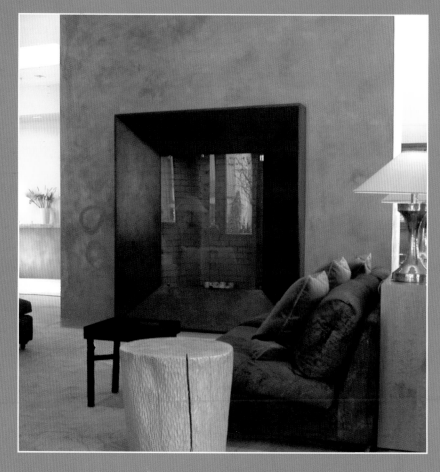

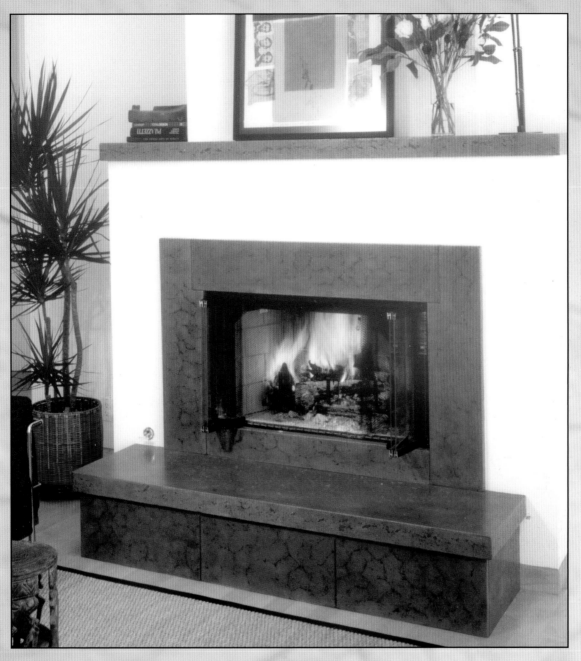

▲ Textures and pigments can be added to concrete in order to give it the appearance of real stone, in this case imitating cut and polished marble. *Courtesy of Buddy Rhodes Studio, Inc.*

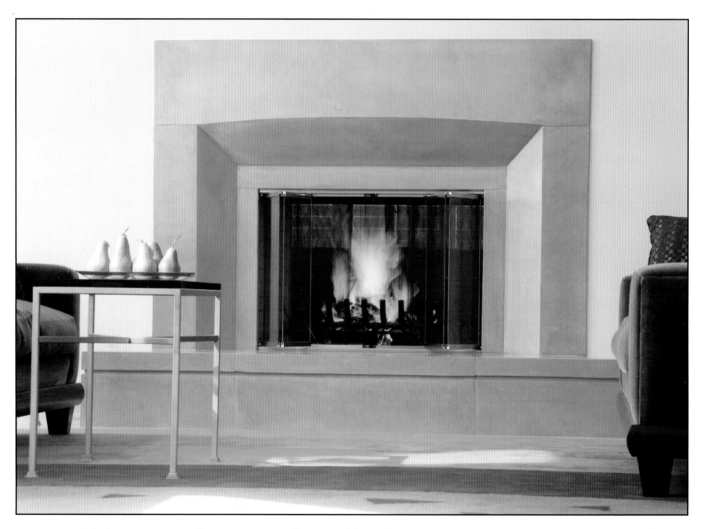

▲A larger surround encompasses the actual hearth to create depth around the fireplace.
*Courtesy of Buddy Rhodes Studio, Inc.*

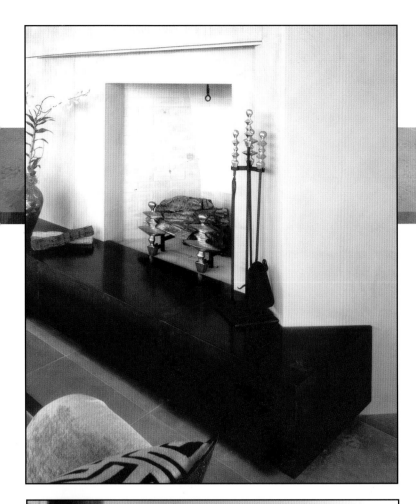

A black raised hearth contrasts with a white fireplace. *Courtesy of Buddy Rhodes Studio, Inc.*

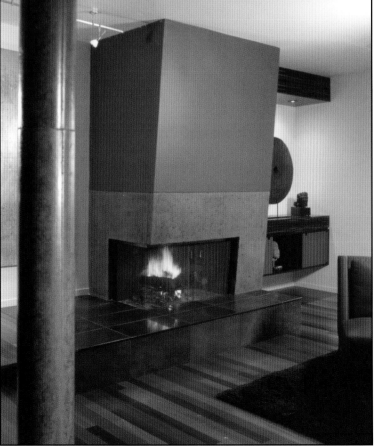

The matching fireplace surround and pillar extend the pattern and color of the concrete tiles into the surrounding room. *Courtesy of Buddy Rhodes Studio, Inc.*

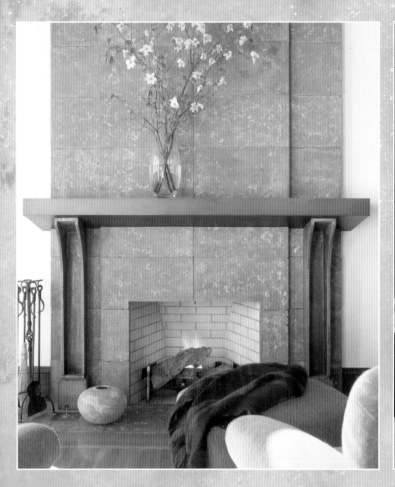

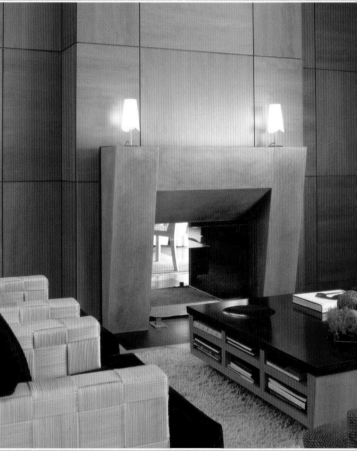

A soaring chimney is decorated with concrete tile panels that imitate cut stone blocks. *Courtesy of Buddy Rhodes Studio, Inc.*

An angled surround for a see-through fireplace complements a room with a modular design. *Courtesy of Buddy Rhodes Studio, Inc.*

Bold blocks of color, from the floor through the red accents of mantel and surround, characterize this room. *Courtesy of Bomanite Corp.*

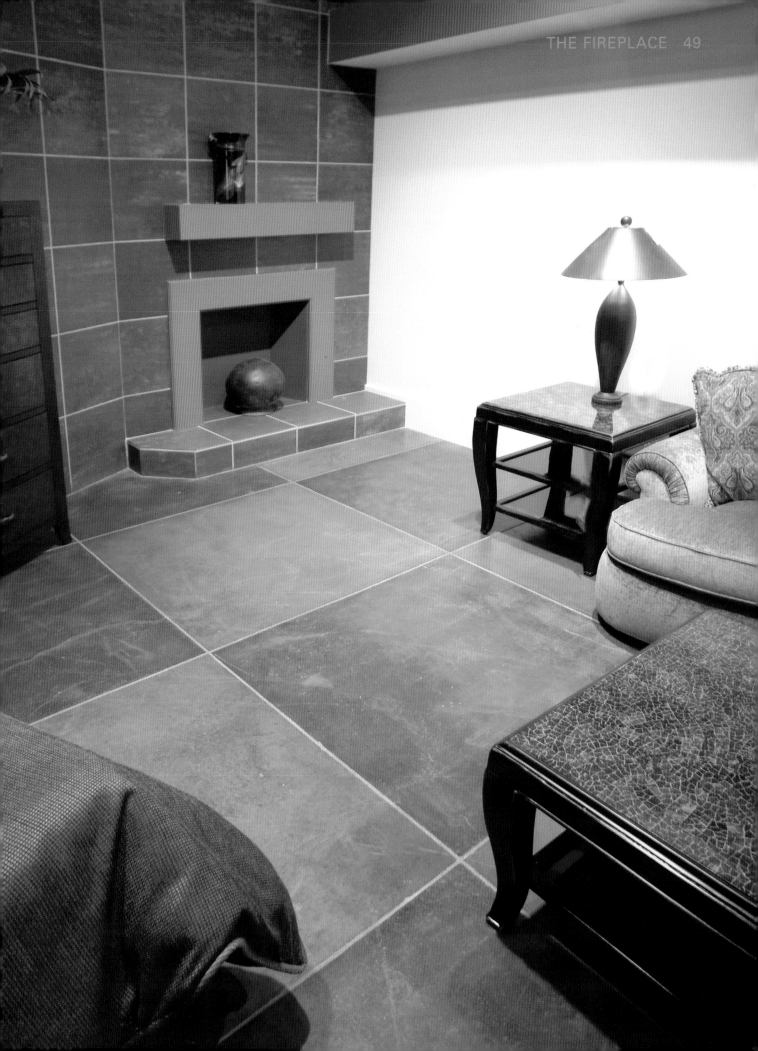

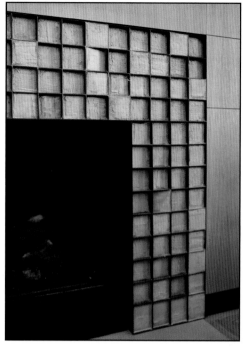

▲▶Concrete was poured into a metal grid to give patterns of varying light, texture, and depth. *Courtesy of Sonoma Cast Stone*

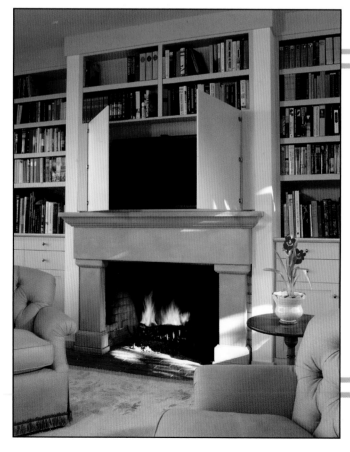

◀Concrete can be cast into shapes, which imitate traditional wood moulding. *Courtesy of Buddy Rhodes Studio, Inc.*

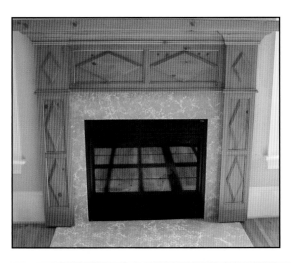

Faux marble was created in concrete for this fireplace surround and hearth. *Courtesy of FormWorks*

A fireplace surround was stamped with a stacked fieldstone pattern. *Courtesy of Yoder & Sons LLC.*

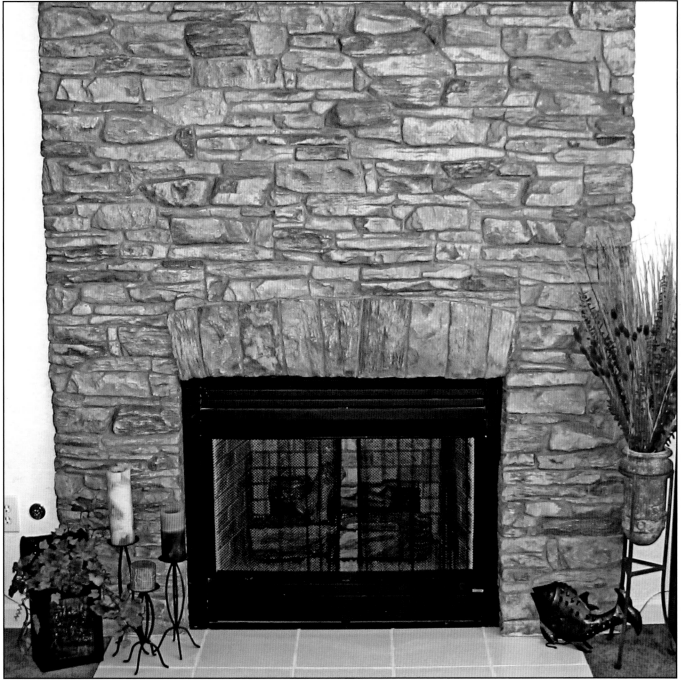

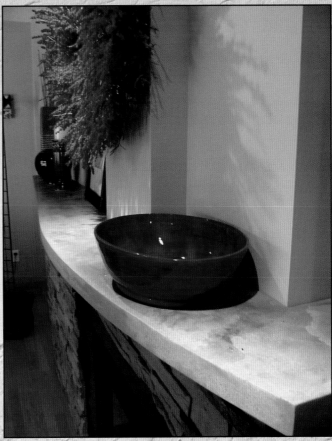

The hearth and mantel in natural gray add a warm accent to this family's living room. The curve softens the formality and attests to the flexibility of concrete applications. *Courtesy of FormWorks*

# Concrete in the Kitchen

Concrete has become the material of choice for designers and homeowners. Decorative concrete, in all of its stained, colored, molded, and personalized glory, is popping up in retail stores, trendy restaurants, offices, and homes everywhere. And leading the charge in the concrete craze is the kitchen countertop. Many are welcoming, embracing, and anxiously pursuing concrete for their own kitchen projects. All it typically takes is one look – whether in a magazine, on a home tour, a television show, or a friend's home – and you're hooked.

Concrete countertops can be left looking natural to complement materials like wood, stone, and brick. Or concrete can be treated with chemical stains, coloring pigments, aggregates, and epoxy coatings that allow concrete to mimic popular materials like marble, granite, and limestone. Moreover, the looks can be personalized, with embedded artifacts and personal mementoes.

Homeowners also have a wide choice in the types of edging that can be achieved with concrete, from edges that mimic the traditional shapes of moulding, to customized looks as varied as the imagination.

▲▶A warm and eclectic contemporary kitchen. Italian Terra Cotta colored concrete is accented with cobalt blue stained concrete. The homeowners personalized their countertops by embedding personal metal items into the countertop. It also features puzzle seams, 1.5-inch and 3-inch thick edges, an integral drain board, integral cutting board recess, hidden vegetable chutes, and a complex back piece custom made for an old porcelain farm sink. *Courtesy of FormWorks*

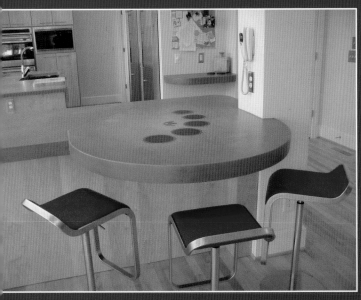

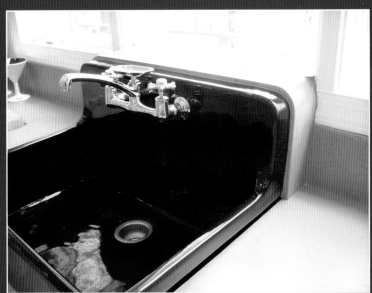

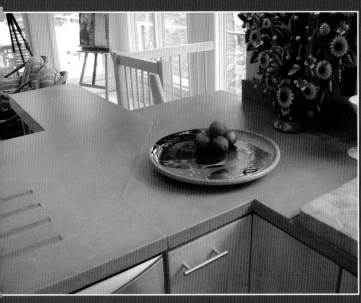

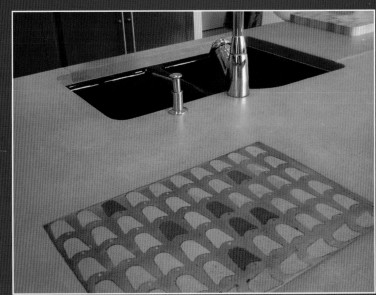

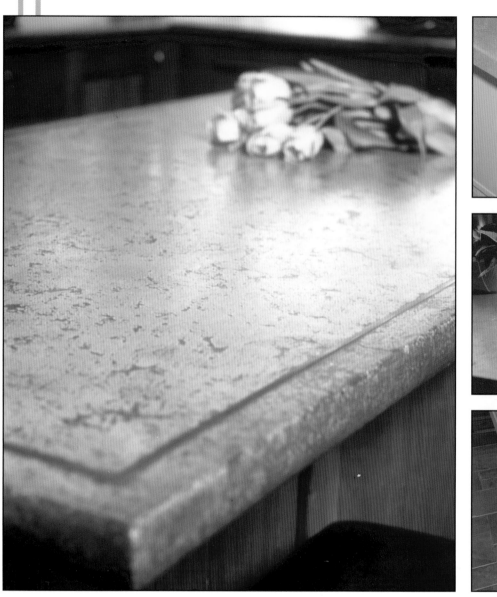

▲Copper inlay provides a simple decoration for this kitchen counter.
*Courtesy of Buddy Rhodes Studio, Inc.*

▲Unlike stone or granite, concrete can be manipulated in endless ways. This highly polished countertop has rounded corners providing visual as well as tactile appeal. *Courtesy of FormWorks*

▶Concrete offers the natural look and feel of stone, while maintaining its unique, custom appeal. *Courtesy of Buddy Rhodes Studio, Inc.*

▼Intricate detailing is possible with concrete as with no other natural material. Here, the countertop has been given an edging that mirrors effects created with wood moldings. *Courtesy of FormWorks*

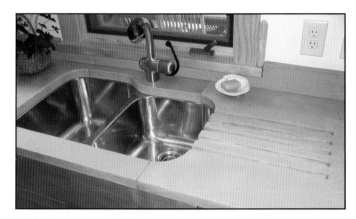

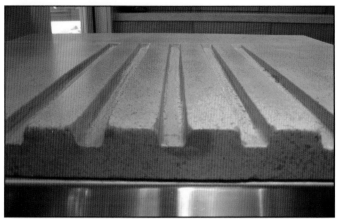

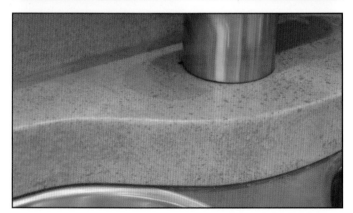

Every concrete countertop contractor has his or her own proprietary construction method. Some of the common points and issues include:

* Countertops are either made onsite (cast-in-place), or produced in a shop and then transported to the project and installed. Fabulous work can be done using either method.

* Countertops are made of cement, lightweight aggregates, and a combination of additives.

* Additives such as fiber reinforcement are used, usually structural steel, wire mesh, fiberglass, and/or fibers. Sometimes more than one type of reinforcement is used.

* The countertops are cured.

* Countertops are often ground or polished to reveal special aggregates such as colored glass.

* Countertops are always sealed. The type of seal, method, and number of coats of sealer is unique to each concrete contractor.

◀▲ This countertop project illustrates the innumerable custom features and built-ins that are possible in concrete. This one includes detailed work around the faucet and windowsill and a custom integrated drain board. *Courtesy of FormWorks*

A 1.5-inch thick, standard concrete countertop weights about 18.75 pounds per square foot, comparable to granite at 18 pounds per square foot. The weight can be less if lightweight concrete is used, but some contractors shun this form of concrete because it has less strength. Standard cabinetry will support the concrete slabs. Two-inch slabs are also quite common, and it is possible to make a thicker countertop if this is desired for aesthetic reasons. If a six-inch slab is desired, the counter will be formed to create a thick front and back for illusion, though the center will still be 1.5 inches thick.

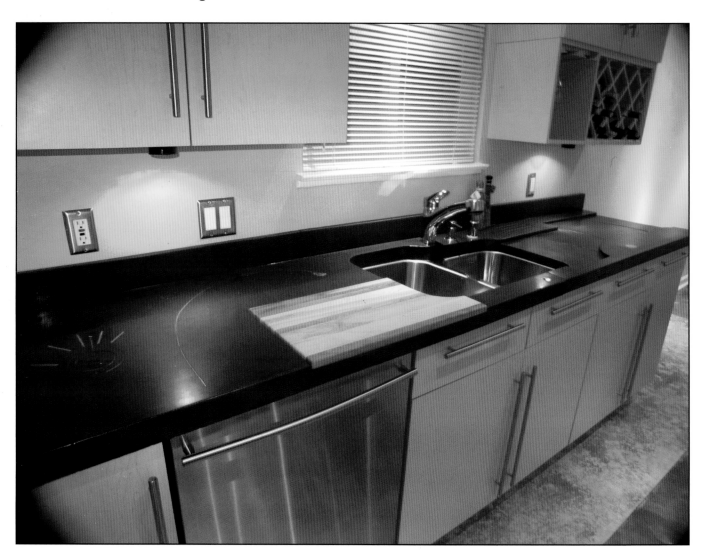

▲ A black countertop has inlayed brass and copper strips, along with colored tiles and ammonites. *Courtesy of Courtesy of Action Concrete Services*

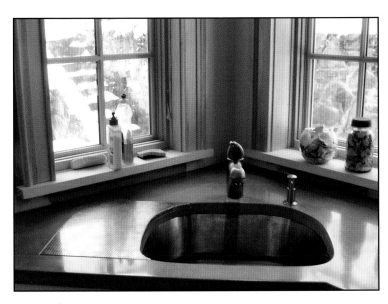

▲Gray concrete matches stainless steel kitchen fixtures.
*Courtesy of The Concrete Impressionist*

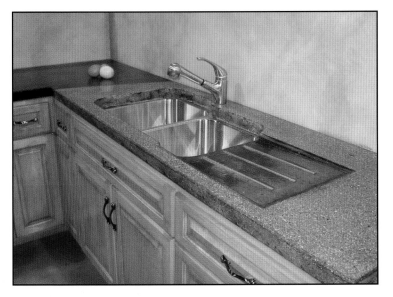

▲A double stainless steel sink was sunk into this granite-like concrete countertop. The level counter was fitted with a sloped drain board. *Courtesy of Verlennich Masonry & Concrete*

Concrete countertops are a custom-crafted material for high-end use and made by designers or architects. Some consumers think of concrete as being a cheaper alternative to other available countertop surfaces. But when you think about buying a concrete countertop, you should do so based on its beauty, artistry, and customization.

Standard 1.5-inch thick concrete countertops range from $65 to $125 per square foot. Other factors such as irregular or curved shapes, greater thickness, integral drain boards, custom edges, and back splashes add to the cost.

In almost all cases, countertop contractors install their own product in their market area, eliminating shipping expenses. Shipping method and carrier, for those firms that do ship, vary by contractor. Installation costs, when the work is done by the countertop contractors, runs from $40-$50 per hour, per person range. Other installations, such as those when the countertop has been shipped, should be done by a contractor experienced in installing countertops. Rates vary by region. The countertops arrive to the site in a completed state, and no modifications should be needed.

Most of the concrete countertop contractors provide detailed installation instructions. Request these instructions and make sure your installer understands them prior to the countertops arriving on site.

Once your countertop is installed, you'll want to take care of it. If left in its natural state, concrete is porous and will stain. Therefore, concrete countertops are sealed for water and stain resistance, and care should be taken to preserve that seal. Your concrete contractor should provide you with instructions for future care. There are a number of things to keep in mind:

* Don't cut on concrete countertops. Though your knife won't hurt the concrete, it will damage the sealer and allow water and staining liquids to penetrate. Always use cutting boards.

* Avoid placing hot pans on concrete countertops. Concrete is very heat resistant, but again, the concern is damage or discoloration of the sealer.

* Consider asking your contractor to build in trivets of steel, brass, or copper. These not only contribute to the total design of your countertop and kitchen, but they're functional, too.

* Avoid abrasive soaps or cleansers.

Like any other material, concrete has properties that require special care and attention. One of the biggest questions that comes up is whether concrete countertops will develop cracks. The answer: not always, but concrete countertops can develop hairline cracks. These tend to be non-structural and result from the natural shrinkage of the concrete. Many people view this unpredictable, imperfect quality as one of the many assets of concrete.

△ The color chosen for this counter is dramatic. Modern features include an integrated drain board and under-mount sink. The nautilus lends a touch of whimsy. *Courtesy of Arends Construction & Design Inc.*

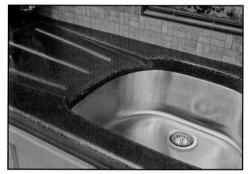

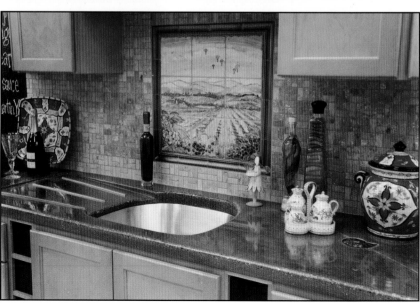

Photography by Lisa Thomas

The countertop needn't stop at the rim of the sink. In many cases, contractors can cast the sink bowl in concrete as well. And there are a number of companies that factory-produce amazing sinks from concrete.

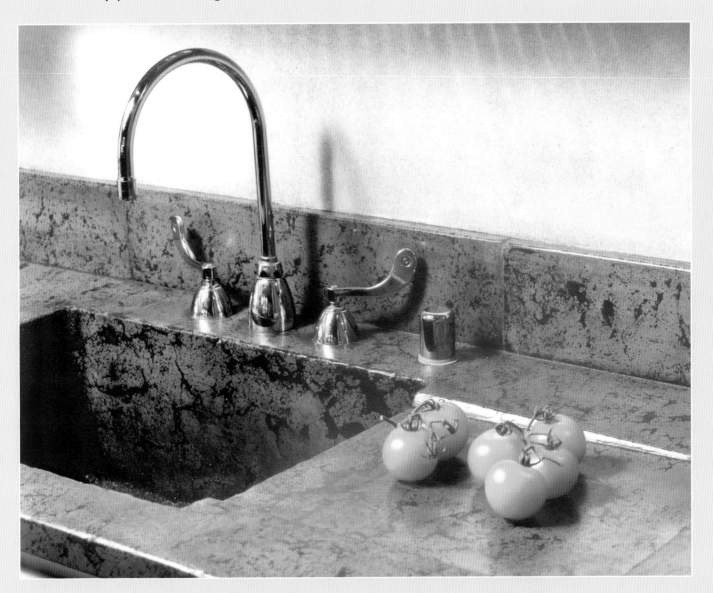

▲This countertop incorporates an integrated sink and drainage board for a streamlined look. *Courtesy of Buddy Rhodes Studio, Inc.*

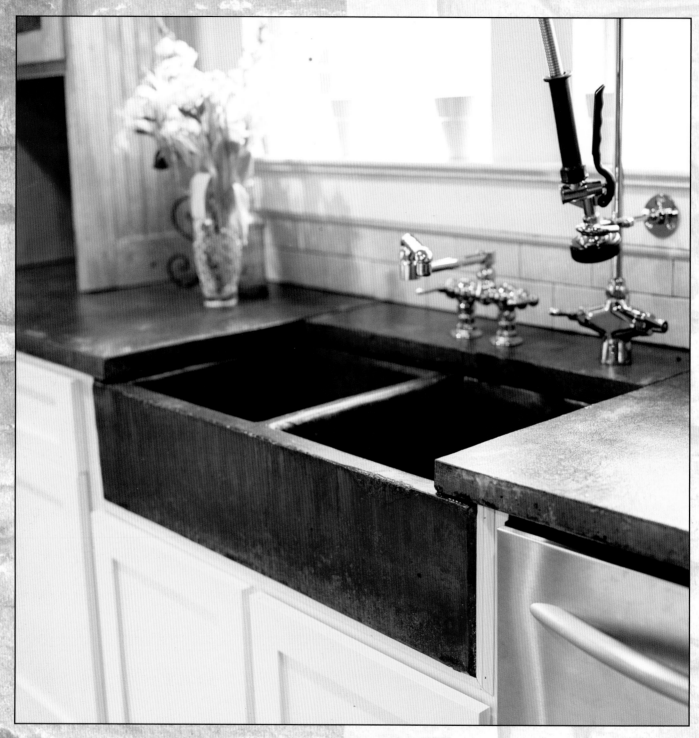

Concrete imparts a rustic, Old World patina to this farmhouse sink and the countertop that crowns it. *Courtesy of J. Aaron Cast Stone*

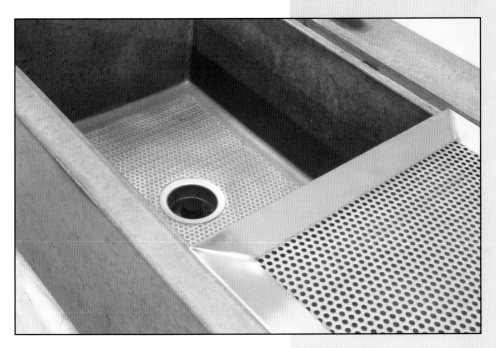

A stainless steel plate with holes has been embedded into the bottom of the sink to help prevent slippage of breakables, as well as abrasion to the cast concrete finish. *Courtesy of Sonoma Cast Stone*

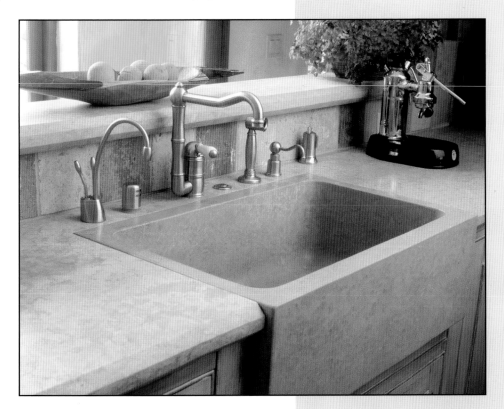

A concrete sink can be colored to match or blend in with the countertop.
*Courtesy of Sonoma Cast Stone*

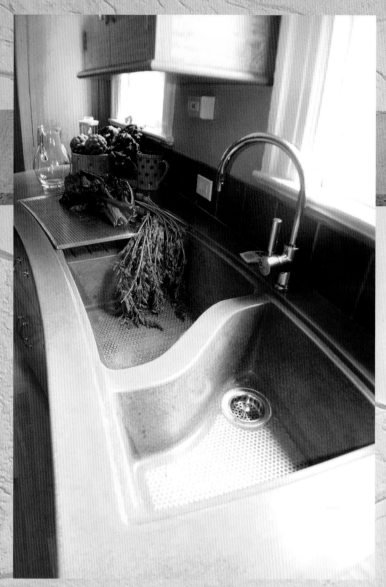

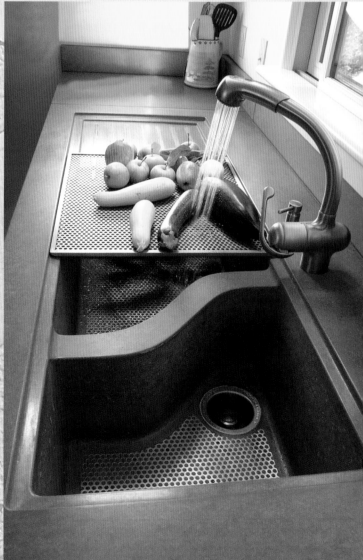

The curved divider between basins makes even an ordinary kitchen sink look sculpted and artistic. *Courtesy of Sonoma Cast Stone*

A stainless steel grate can slide the entire length of the sink and serves as a large strainer or creates some extra counter space. *Courtesy of Sonoma Cast Stone*

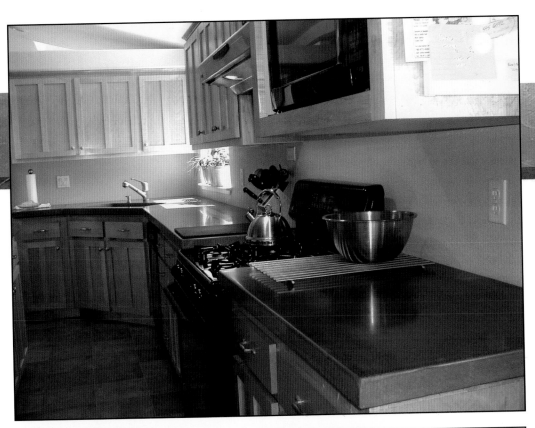

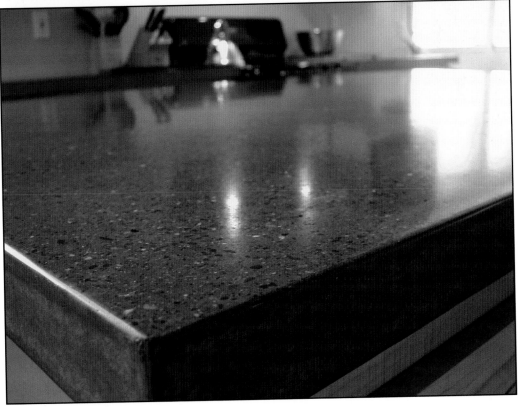

The designer chose simple gray countertops for a utilitarian kitchen. A heavy grind exposed a lot of aggregate as well as abalone shells sprinkled throughout. *Courtesy of Xtreme Concrete*

▶The backsplash has been cast in a mini-cobblestone brick pattern. The gray counters contrast with the red walls in this kitchen. *Courtesy of WorkSpace*

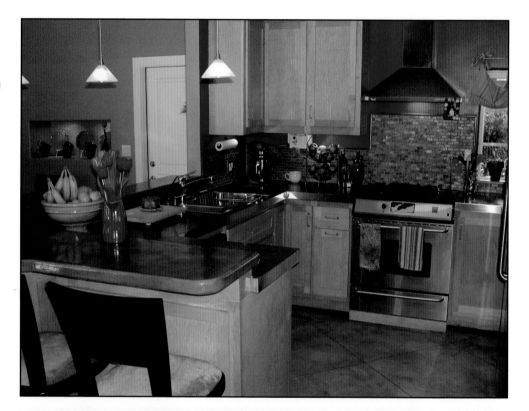

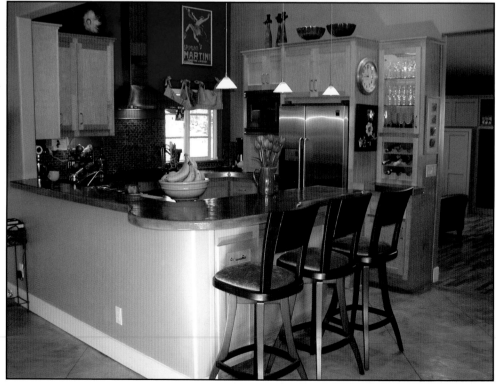

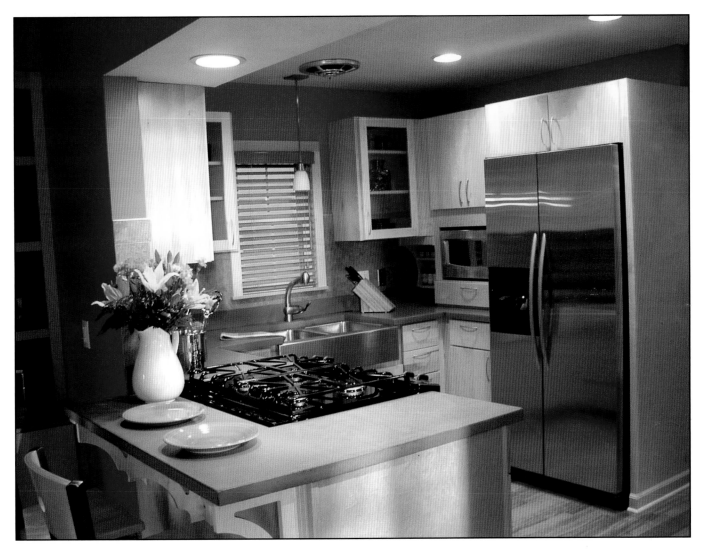

▲ Concrete countertops can be the most unique feature of your kitchen. Each countertop is designed to the homeowner's personal specifications and the material takes on a rich patina over time. *Courtesy of Verlennich Masonry & Concrete*

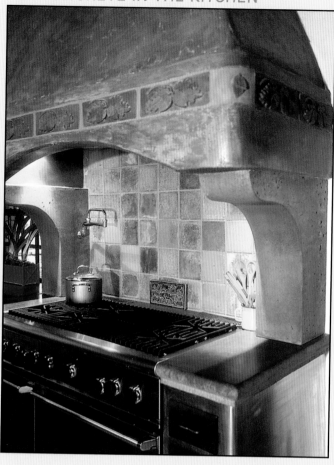

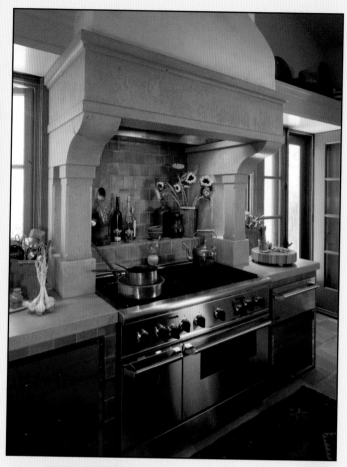

▲The decorative plaques pressed into the front of this surround, coupled with the varying colors of the concrete tiles on the backsplash give this kitchen its unique, Old World character. *Courtesy of Sonoma Cast Stone*

◀Surrounds can be used in the kitchen as well as around a fireplace. Here, a surround shelters the kitchen stove and ornaments an exhaust hood. *Courtesy of Sonoma Cast Stone*

▶Since it's so sculptural when wet, concrete can be customized to fit any owner's designs very easily. The countertop on this island features an opening that leads to a waste bin beneath. *Courtesy of Sonoma Cast Stone*

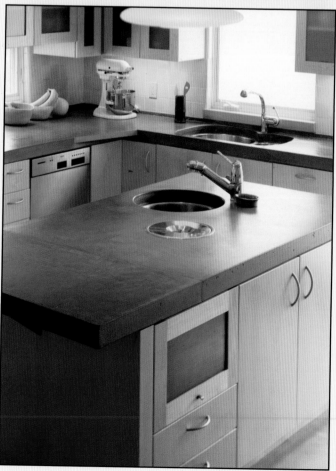

◀▼A trowel finish adds sheen to a concrete surface. *Courtesy of Buddy Rhodes Studio, Inc.*

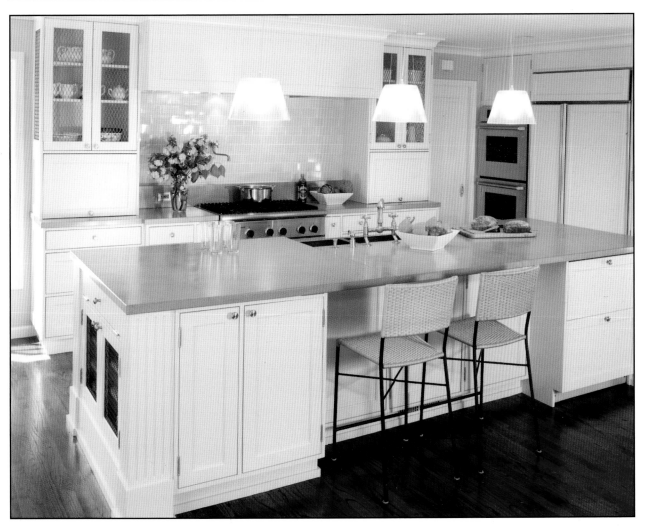

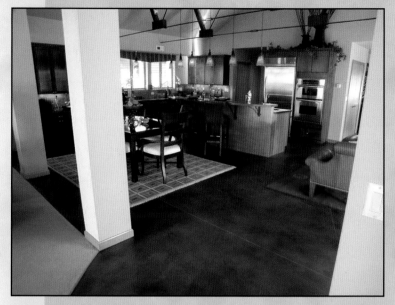

▶Concrete flooring was stained to lend the warm undertones of turf to this expansive kitchen and gathering area.
*Courtesy of Skookum Floors, USA*

▶A large circle dominates a dynamic interplay of circles and squares.
*Courtesy of Buddy Rhodes Studio, Inc.*

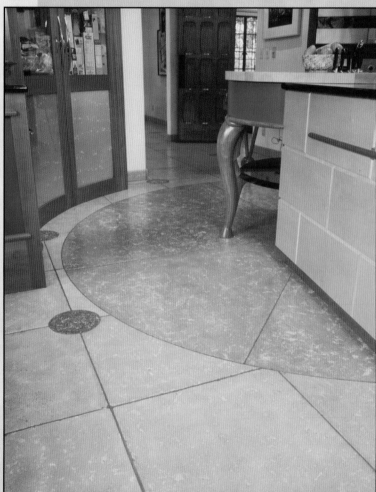

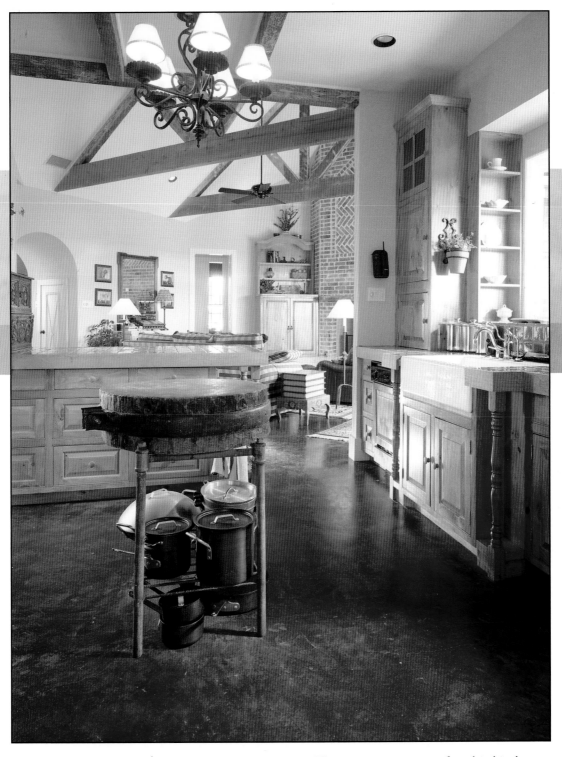

▲Old World beauty adorns modern day luxury. The staining process for this kitchen floor created a natural stone or mottled appearance that instantly adds character to this kitchen. *Courtesy of Kemiko Concrete Stains*

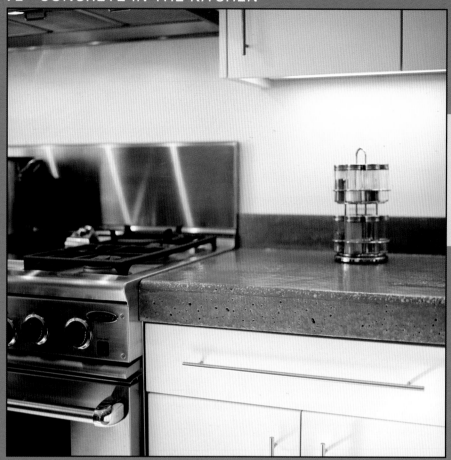

◀A green sheen countertop adds earthy element to a stainless steel and white laminate environment. *Courtesy of J. Aaron Cast Stone*

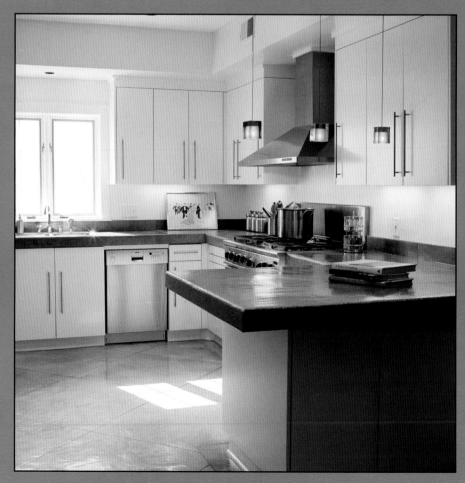

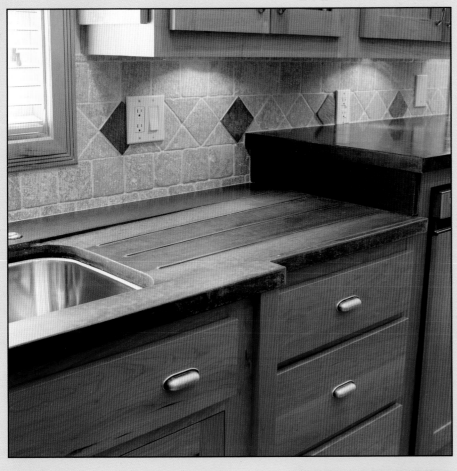

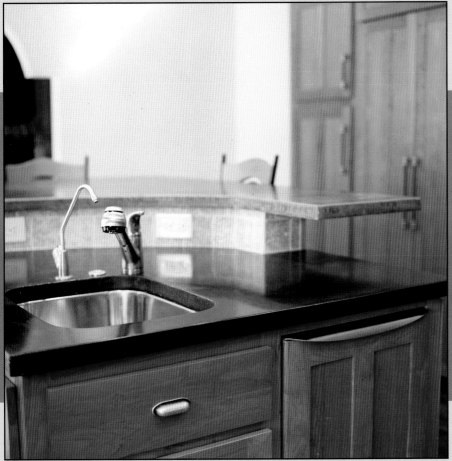

◄A perfect complement to highly textured tile and rich woodwork, this concrete counter and drain board was stained a rich, dark gray. The waxed shine of the island and raised counters was not incorporated in the drainage area, creating an area where friction will help prevent slippage and breakage of porcelain and glassware. *Courtesy of J. Aaron Cast Stone*

▶Terracotta tones on a concrete floor serve to accent the light-colored furnishings in this kitchen. *Courtesy of Bomanite Corp.*

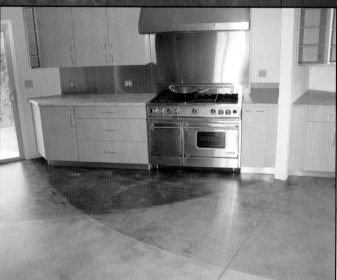

▶Broad swathes of color on the floor bring out the neutral colored countertop. *Courtesy of Bomanite Corp.*

▼An undercounter sink set in an island countertop gives it a smoother look. The tan colored countertop adds warmth to this kitchen. *Courtesy of Buddy Rhodes Studio, Inc.*

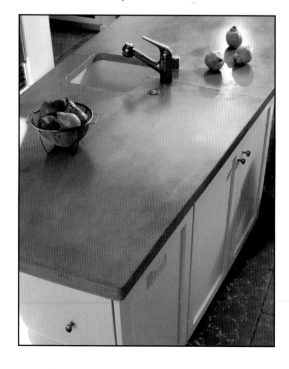

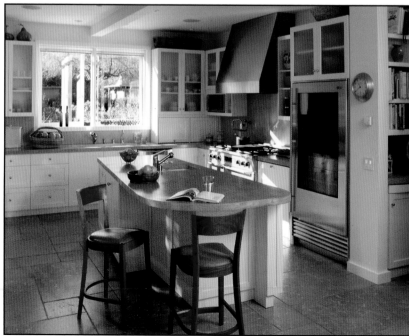

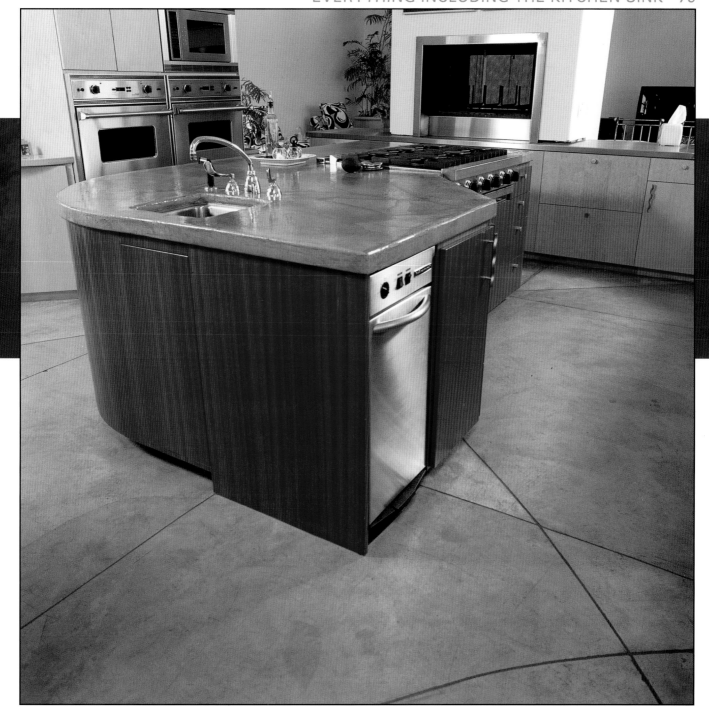

▲ The natural gray tones of the concrete flooring and countertops
go well with stainless steel appliances. *Courtesy of Bomanite Corp.*

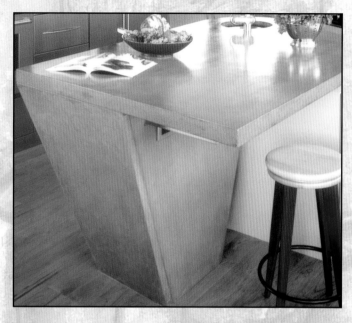

▲ Concrete panels were created to match the countertop on this kitchen island. *Courtesy of Buddy Rhodes Studio, Inc.*

▶ A proprietary concrete formula, extremeconcrete®, was selected for this room rich in natural and architectural textures. *Courtesy of Meld USA, Inc.*

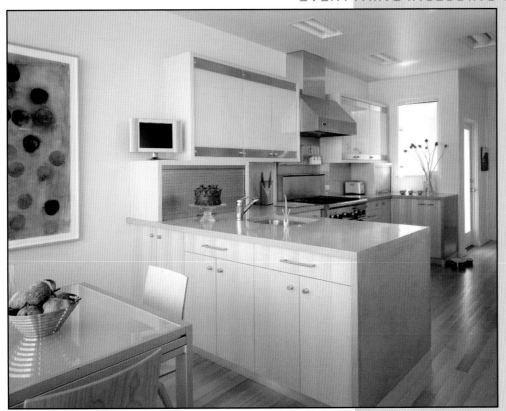

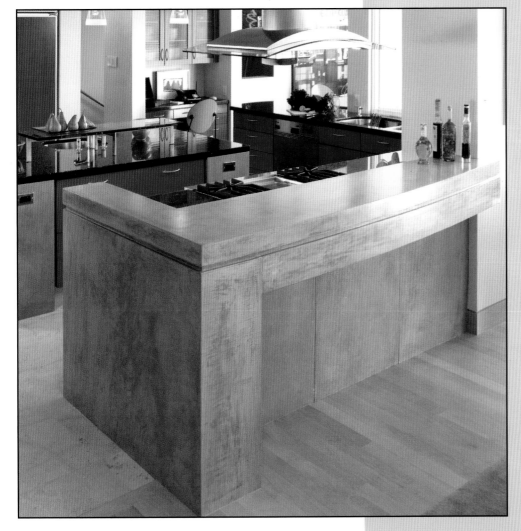

◀ A concrete end panel caps a peninsula of cabinetry protecting the wood cabinets from scuffs and scratches in a high-speed kitchen. *Courtesy of Buddy Rhodes Studio, Inc.*

◀ A family of neutral tones was married in concrete flooring, counters, and kick panels. *Courtesy of Buddy Rhodes Studio, Inc.*

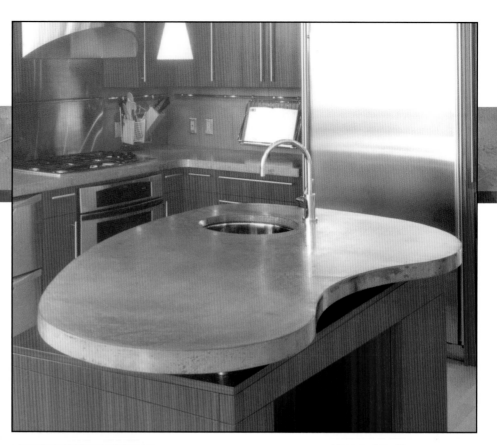

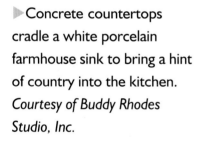Starting as a liquid, concrete can be cast in a variety of shapes and lends itself very well to curves. Here a kidney-shaped countertop was pre-cast and fitted to a rectangular island with an undercounter sink. *Courtesy of Buddy Rhodes Studio, Inc.*

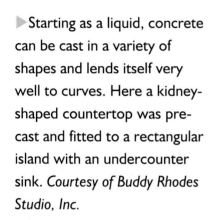Concrete countertops cradle a white porcelain farmhouse sink to bring a hint of country into the kitchen. *Courtesy of Buddy Rhodes Studio, Inc.*

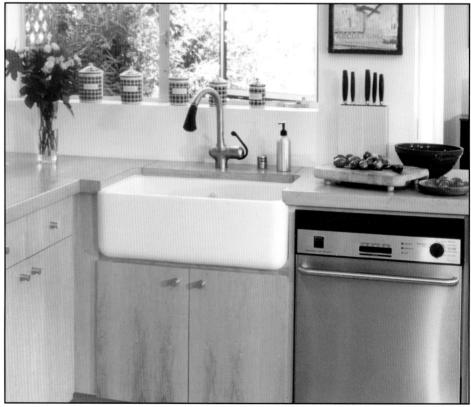

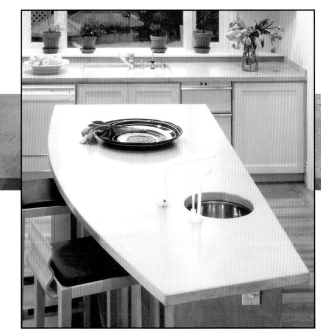

◀▼Concrete serves as the surface and backsplash of an island and countertops. *Courtesy of Buddy Rhodes Studio, Inc.*

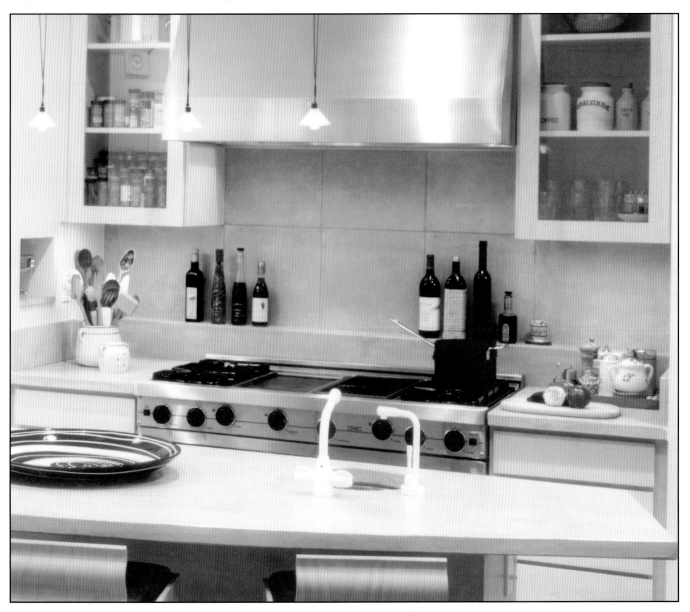

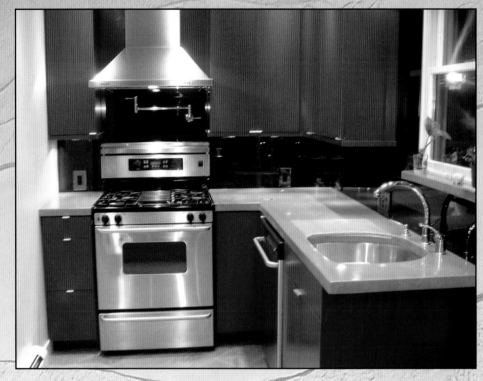

A light colored countertop contrasts nicely with dark kitchen cabinetry. *Courtesy of The Concrete Impressionist*

A sculpted edge and mosaic tiles set into the concrete splashboard give this island top a beautiful, classic look. *Courtesy of Concrete Tops of Winter Park L.L.C.*

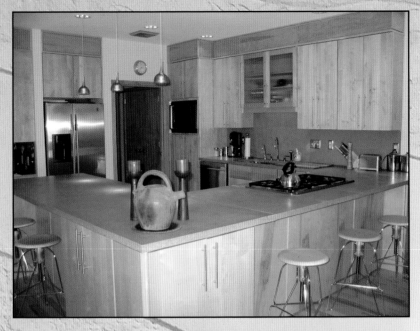

Many homeowners are choosing concrete as much for practicality as beauty. Here, the counter and backsplash were given a subtle color treatment, perfect for this light-filled kitchen. *Courtesy of FormWorks*

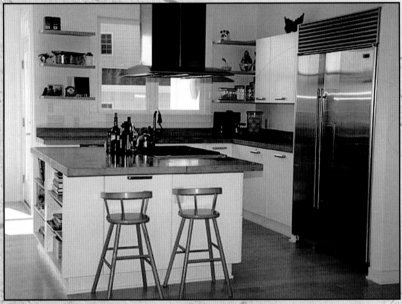

Perfectly suited for the clean spare lines of contemporary homes, concrete was used for counter surfaces throughout. *Courtesy of FormWorks*

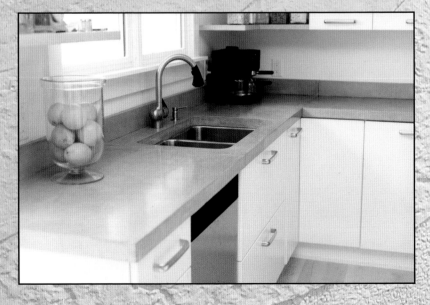

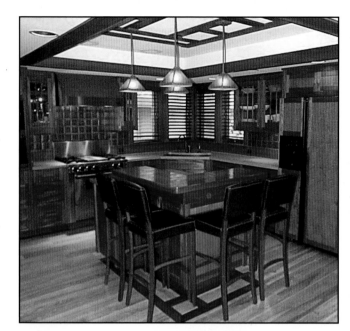

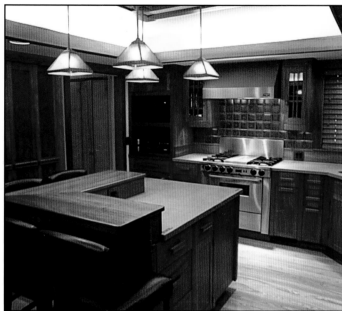

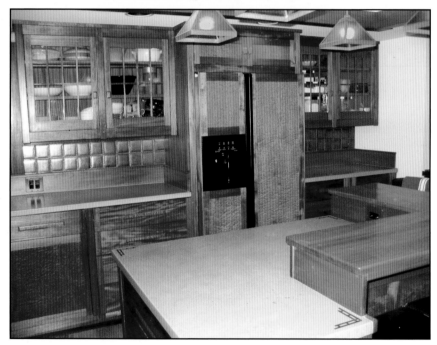

▲Giving each area its own treatment helps to define spaces. The island's food prep area has been finished in a light color and given a corner decorative treatment that echoes the floor design around the island. The boundaries of the raised breakfast bar are defined by color as well as height. *Courtesy of FormWorks*

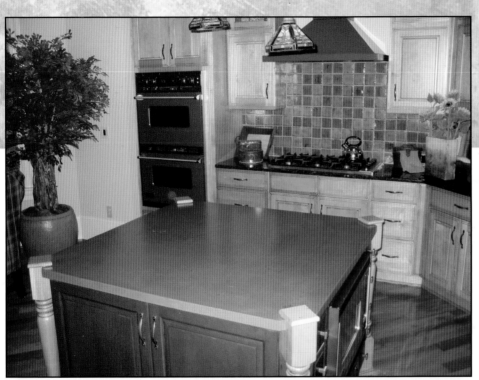

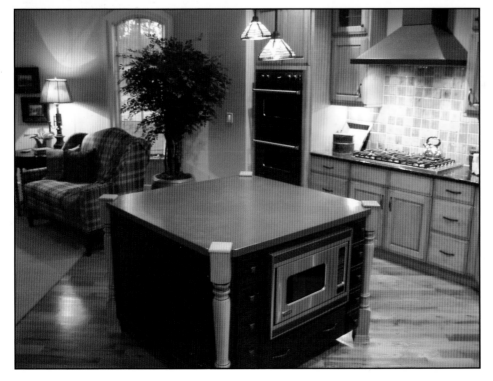

◀▲Achieve a look that is uniquely yours. Here, the homeowners chose both concrete and granite countertop surfaces. Concrete offers wonderful ways to personalize your home, as in the corner detail. *Courtesy of FormWorks*

▼▶Warm red and charcoal gray countertops tie together the cabinetry. Red accent squares coordinate with the drawer hardware and provide a personalized touch. The island has a long custom-designed curve and a 3-inch thick edge. *Courtesy of FormWorks*

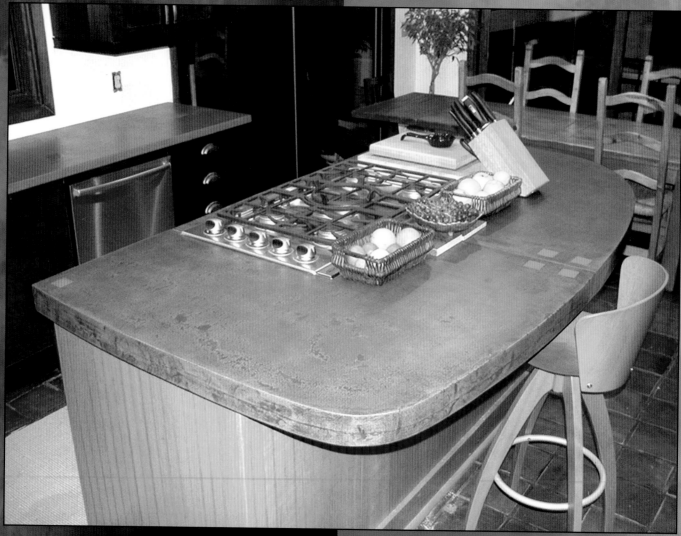

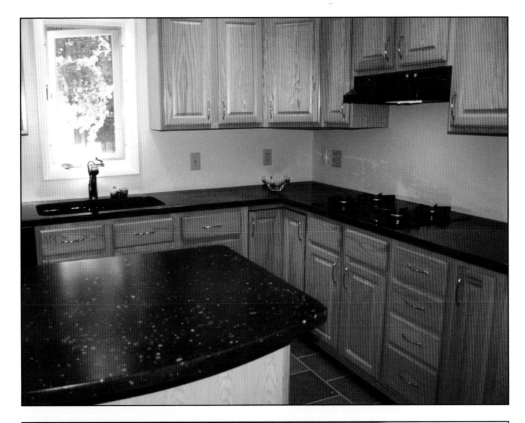

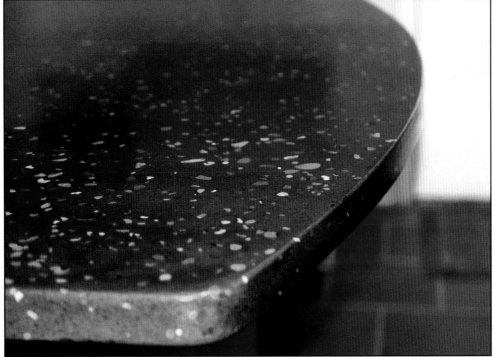

▲A study in contrasts, warm wood cabinetry and cool black concrete countertops are softened by rounded edges and a sprinkle of color. *Courtesy of FormWorks*

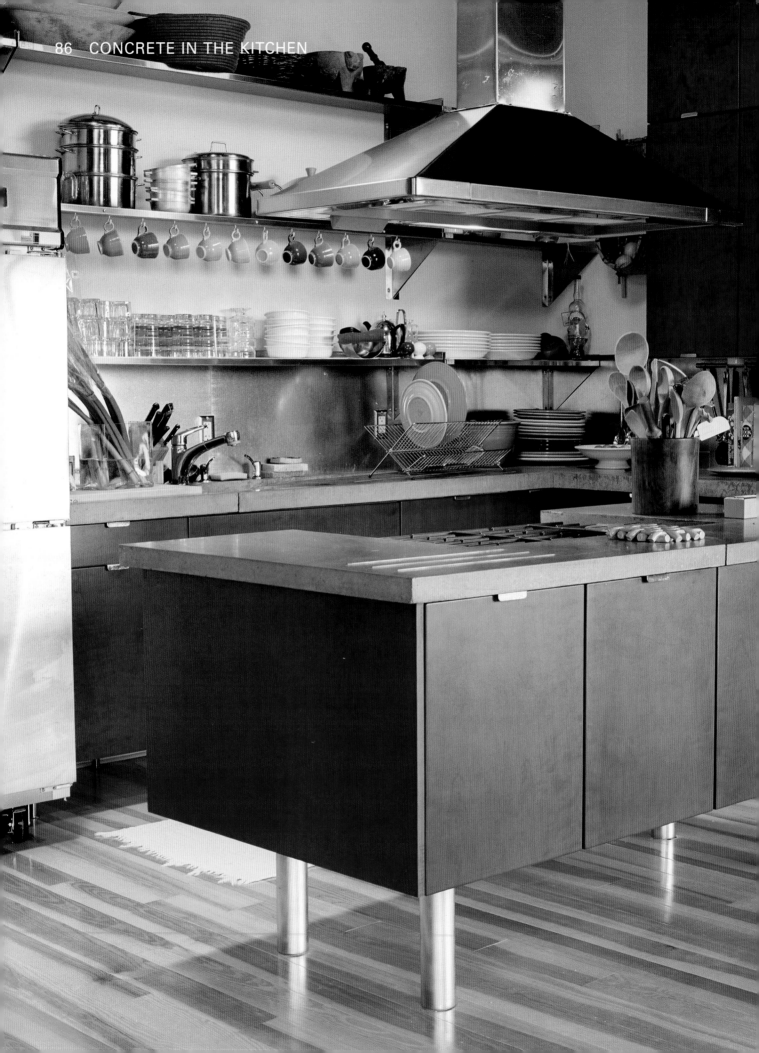

◀ Here, concrete was chosen for the island work surface as well as countertops, providing a cohesive look to this stylish kitchen. Notice the three lines ground into the foreground of the island counter. These indentations allow for heat dispersion, creating a place where a hot pot or platter can be set directly on the surface. *Courtesy of J. Aaron Cast Stone*

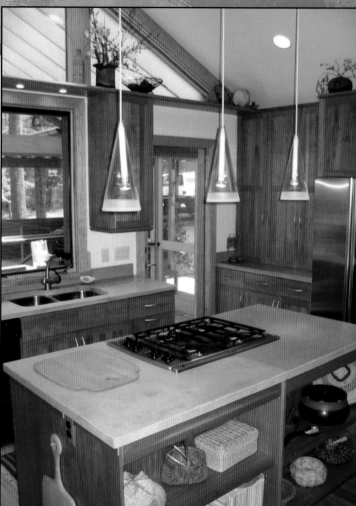

Warm cherry wood and Asian accents set the tone for this kitchen. *Courtesy of FormWorks*

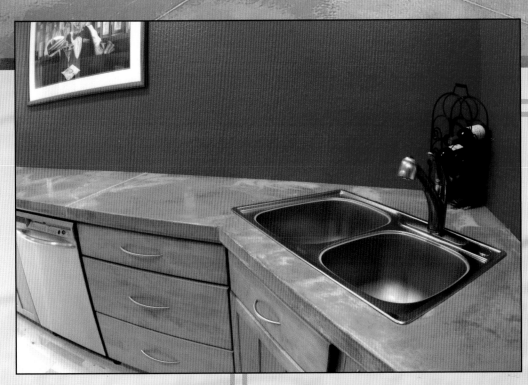

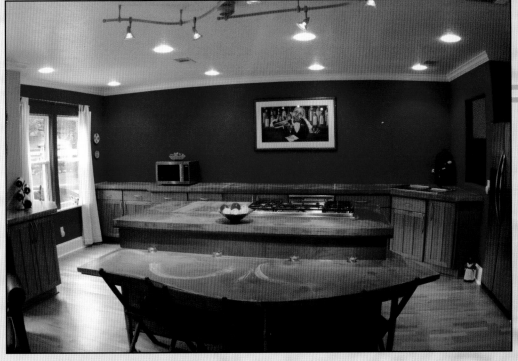

◀▼Staining on this countertop mimics the appearance of aged terracotta. The island features an integrated range and cutting board, and shows how concrete can be both functional and decorative. *Courtesy of Concrete Tops of Winter Park L.L.C.*

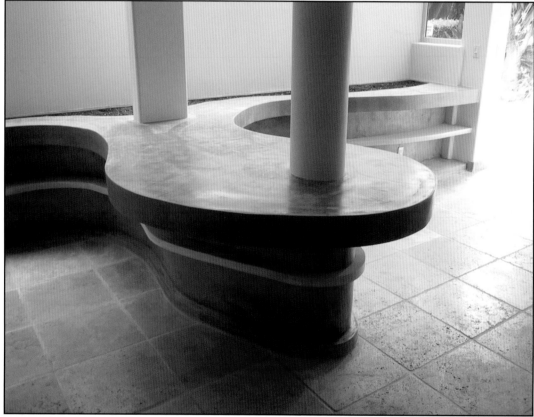

▲A complicated, continuous-pour countertop was the most appropriate material for this ultra-modern kitchen, which bridges the divide between indoors and out in sunny California. The design allowed for a feeling of planters along the extended seating area. The stone floor surface was slightly graded to allow for water drainage during rare rain storms. *Courtesy of DeWulf Concrete*

# Baths and Powder Rooms

After the kitchen, a bathroom is the room most likely to be remodeled in the home. Today's trend is toward transforming the bathroom, the master bath in particular, into a private sanctuary – a retreat in which to escape and relax at the end of the day. Achieving that often entails soothing whirlpool tubs, multi-jetted showers, and sinks and vanities made in various forms, textures, and colors to complement the tranquil atmosphere of the bathroom.

Concrete is quickly emerging as an exciting new option in upscale bathroom remodels. Concrete sinks, vanities, and concrete tub and shower surrounds are gracing bathrooms in homes across the country. Concrete offers homeowners a vast range of colors and textures to complement the other materials in their bathrooms, and the product range available is mushrooming.

## Concrete Sinks

Many homeowners and designers are finding that concrete sinks are a perfect fit for achieving a distinctive-looking bathroom. Because concrete can be poured to shape any form, concrete fits the bill for any type of sink imaginable: above-the-counter vessel sinks, pedestal sinks, bowl sinks. Even wave sinks, trough sinks, and traditional-style counter sinks.

Whether square, rectangular, oval, round, or integral, concrete can be shaped to blend into any bathroom décor and style.

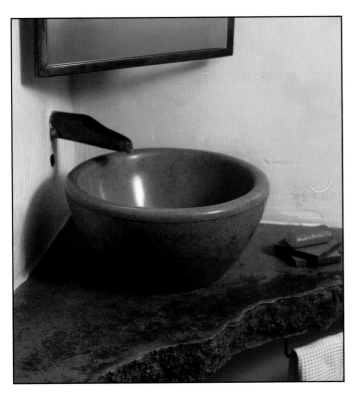

▲The rough, broken-looking edge of the counter gives this vanity a rustic look. *Courtesy of Sonoma Cast Stone*

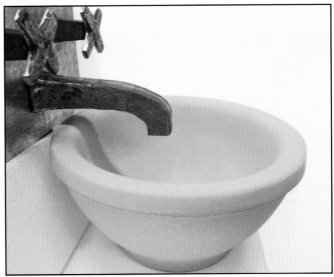

▲A completely round basin like this one can be set into a bathroom counter at any height. *Courtesy of Sonoma Cast Stone*

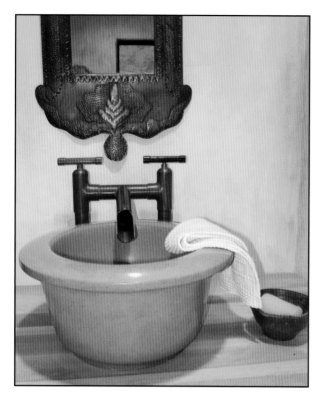

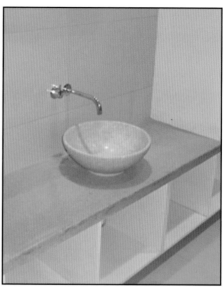

▲To create a glossy look, this sink was heavily polished and treated with a special finish. *Courtesy of Sonoma Cast Stone*

▲This concrete sink is shaped like a washbasin and appears separate from the counter. *Courtesy of The Concrete Impressionist*

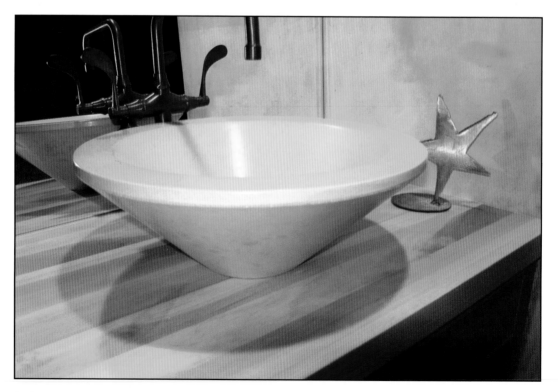

▶Shiny white concrete looks a lot like porcelain and is much stronger. *Courtesy of Sonoma Cast Stone*

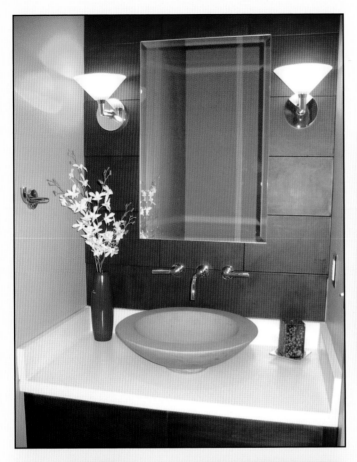

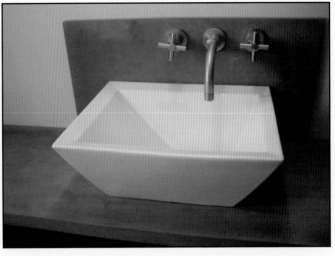

▲A modern, asymmetrical vessel sink is framed by smooth, natural gray concrete. The matching backsplash provides a practical and aesthetically effective backdrop for the sink and faucet. *Courtesy of FormWorks*

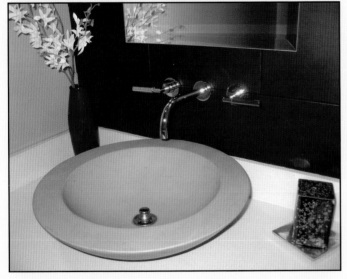

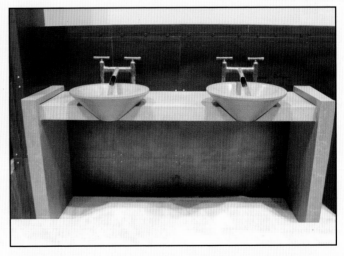

▲Clean contemporary lines distinguish this raised bathroom sink, the concrete countertop, and the backsplash. *Courtesy of FormWorks*

▲Sink basins raised above the surface of the bathroom counter create an interesting assembly of parts. *Courtesy of Sonoma Cast Stone*

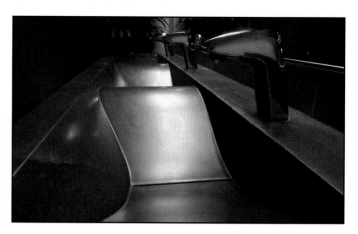

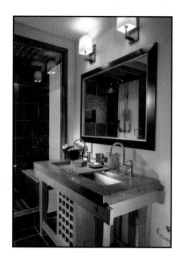

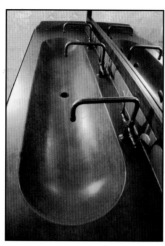

▲The undulation of the basin in this sink resembles waves of water. *Courtesy of Sonoma Cast Stone*

▲Concrete creates a modern look for an under-counter trough sink vanity. Matching bricks also line the entrance to the shower. *Courtesy of Buddy Rhodes Studio, Inc.*

▲The size and shape of this trough sink lend themselves very well to use in public restrooms. *Courtesy of Sonoma Cast Stone*

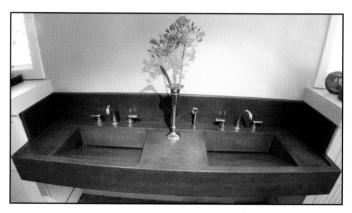

▲A dark colored vanity with sloping basins creates a unique look for this washroom. *Courtesy of Sonoma Cast Stone*

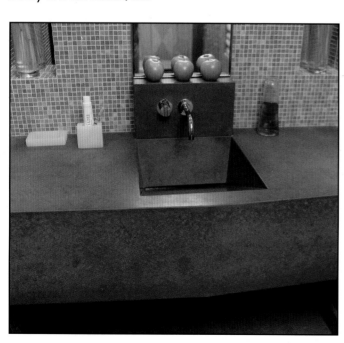

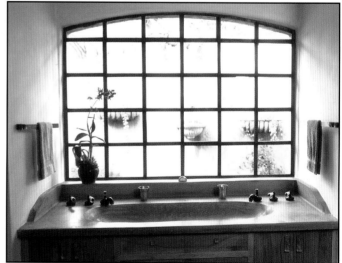

▲A concrete sink with a sloping basin is reminiscent of an antique laundry sink from Tuscany. *Courtesy of Sonoma Cast Stone*

▲The shape of this sink was modeled after the public washing troughs found in Tuscany. *Courtesy of Sonoma Cast Stone*

Concrete is an ideal choice for the bathroom vanity because it can be cast to accommodate existing plumbing configurations and space restrictions.

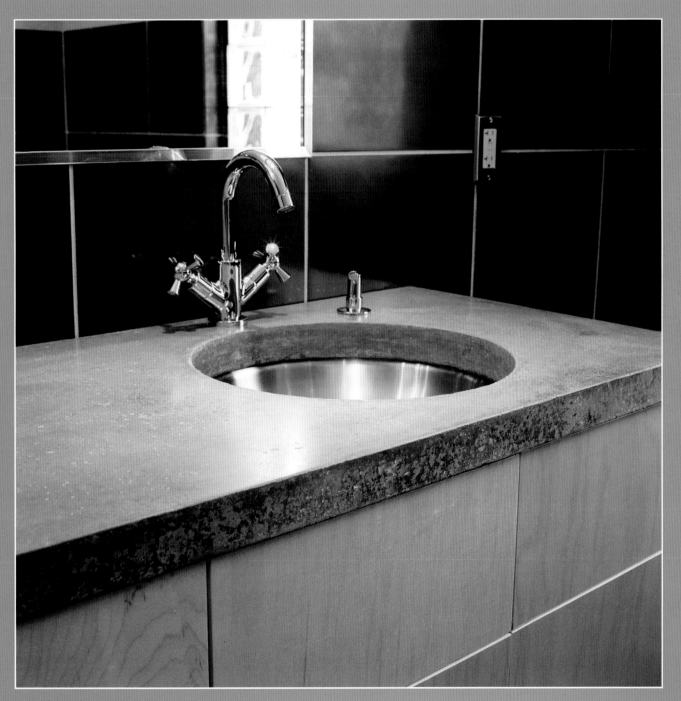

▲The thickness of this concrete slab is exhibited both in the flat edge and the drop to a sunken stainless steel bowl. *Courtesy of J. Aaron Cast Stone*

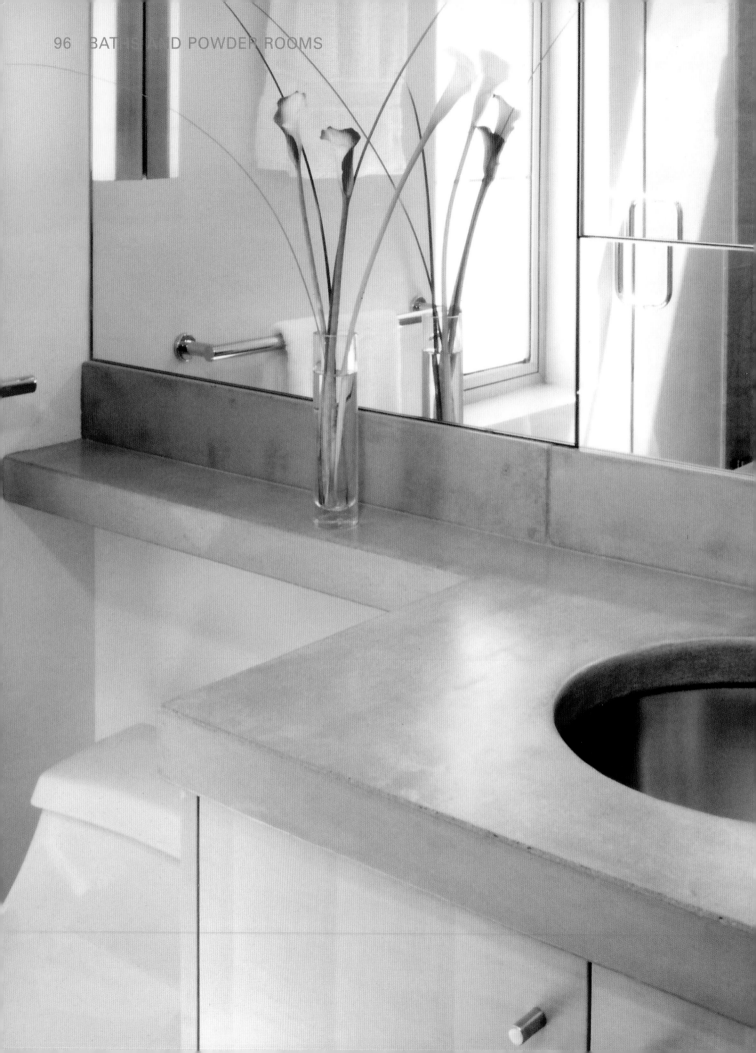

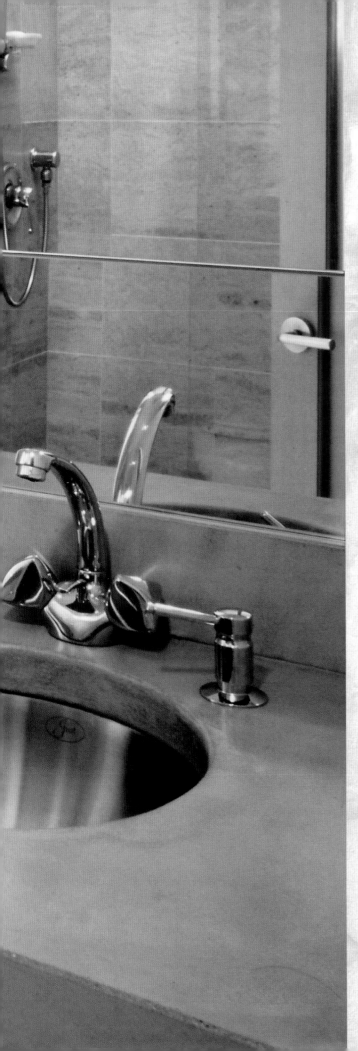

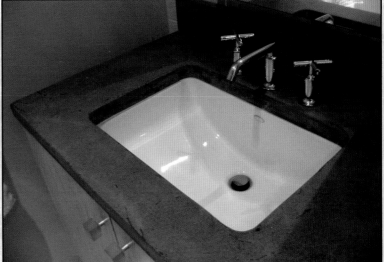

As durable as the concrete it's made of, the counter and under-mount sink in this bathroom will provide long lasting beauty. *Courtesy of FormWorks*

A decorative ledge was extended behind the toilet. *Courtesy of Buddy Rhodes Studio, Inc.*

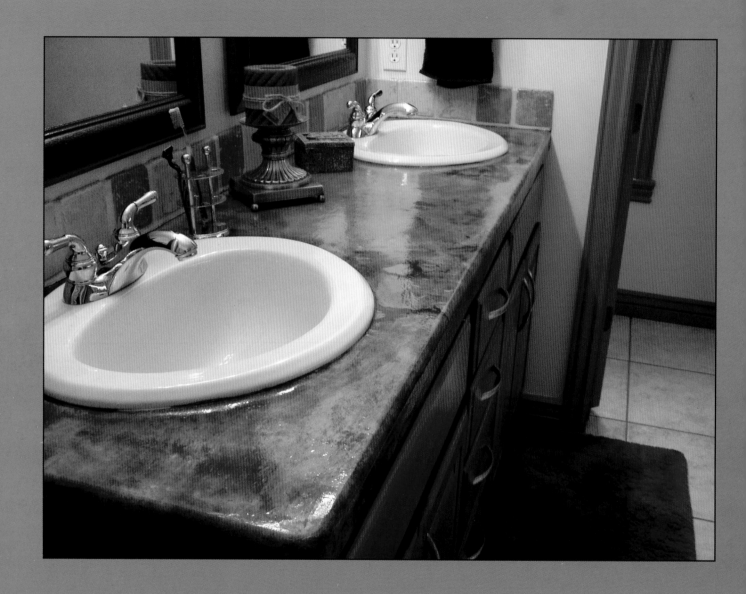

▲Decorative concrete tiles along the backsplash of this vanity work to further enhance the color of the concrete countertop. *Courtesy of Bomanite Corp.*

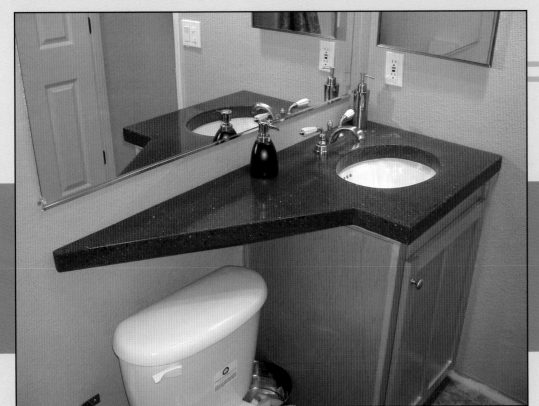

◀▼An angled vanity top provides storage space in a small bathroom. *Courtesy of Xtreme Concrete*

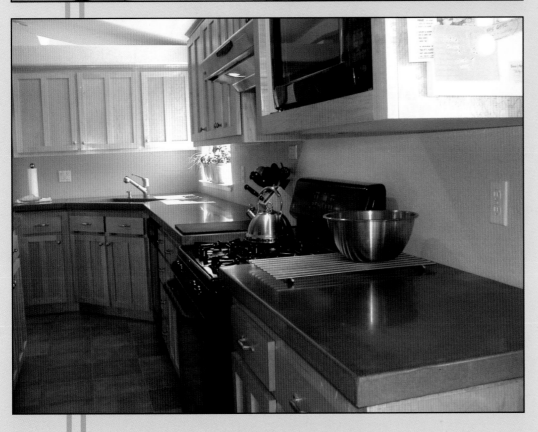

▶A crack may make you imagine this is an antique marble sink. *Courtesy of Concrete Concepts Inc.*

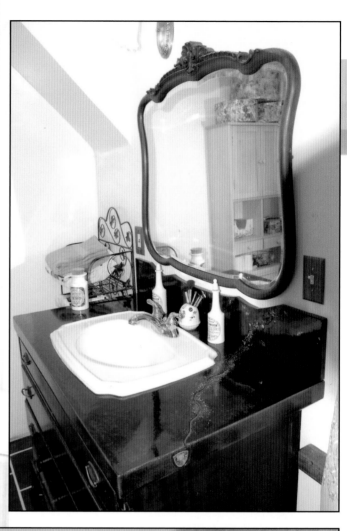

▶A dramatic architectural statement. *Courtesy of FormWorks*

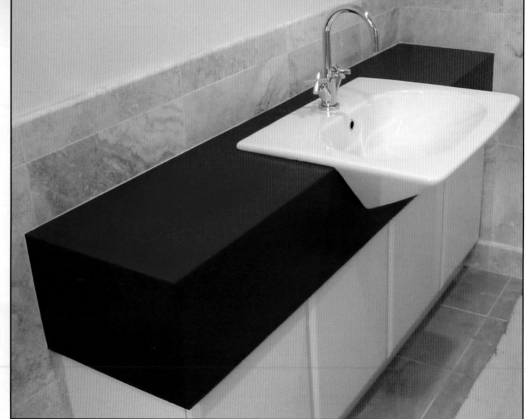

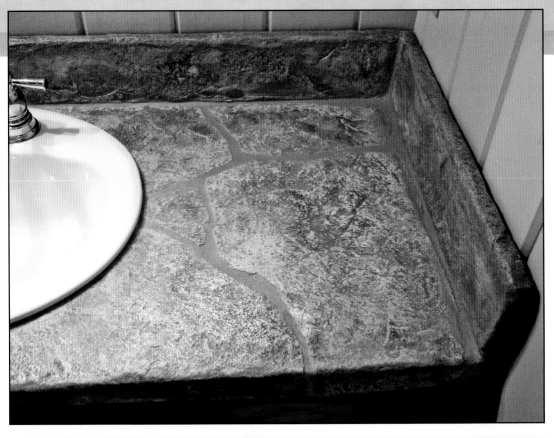

◀A random stone pattern is put to use on a bathroom countertop. *Courtesy of Yoder & Sons LLC*

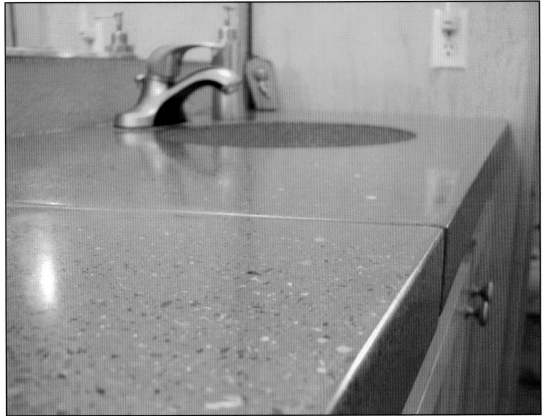

◀Terrazzo originates in Italy and was used extensively as a decorative surface in the 1930s and '40s. This type of decorative concrete is once again becoming popular. *Courtesy of WorkSpace*

Photography by Lisa Thomas

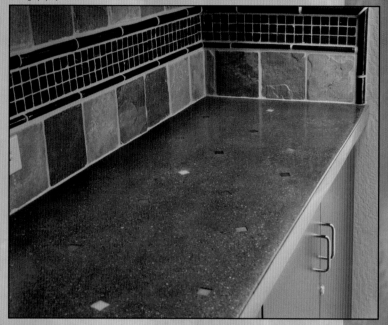

◀This countertop has been given a playful series of colored insets. Concrete also mimics tile in tiers of texture and tone on the backsplash. *Courtesy of Arends Construction & Design Inc.*

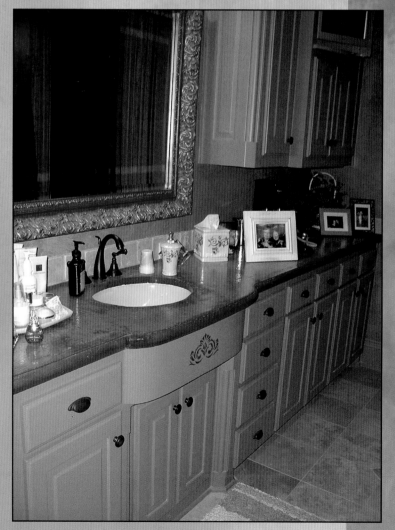

◀A concrete vanity top in a bathroom area might easily be mistaken for marble. *Courtesy of The Ultimate Edge, Inc.*

If you feel limited by tile, marble, or granite, concrete is a great choice for tub and shower surrounds. Because concrete can be poured to fill any form, any shape of surround can be created. So if you're dreaming about a round shower surround, it can be done with concrete. Whether you're seeking angular lines or soft curves, concrete fits the bill. Whether you're aiming for a smooth, seamless look, or a blocked-tile look, you can get it with concrete.

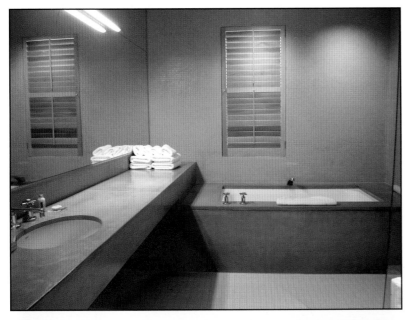

◀A vanity rests on the edge of a bathtub surround, together forming a substantial statement within a minimalist environment. *Courtesy of Buddy Rhodes Studio, Inc.*

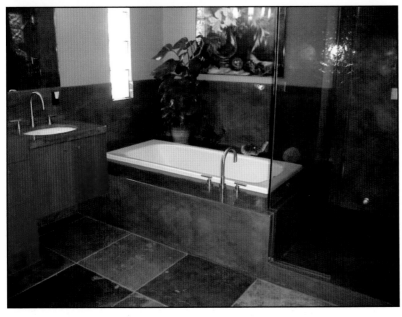

◀Because finished concrete does not retain water or other liquids, the surfaces from floor to hip height will be easy to maintain. *Courtesy of Bomanite Corp.*

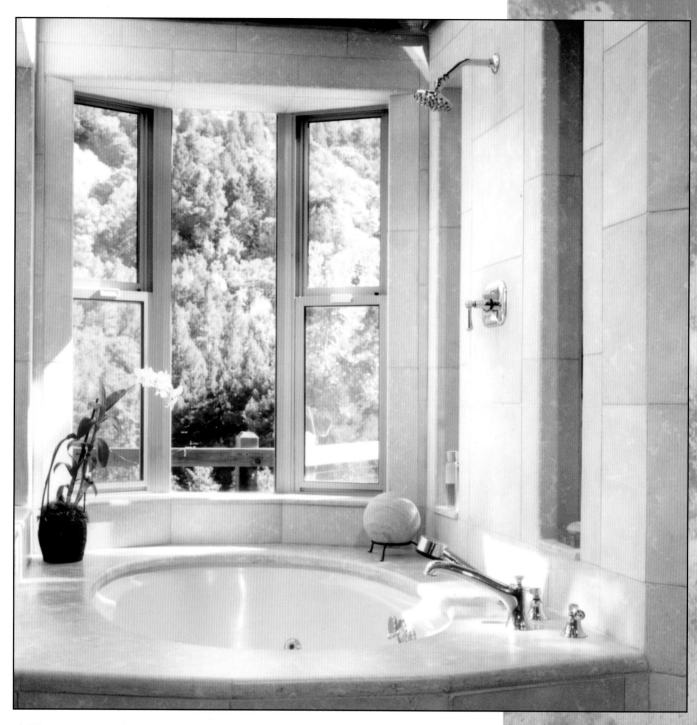

▲The concrete tiles in this bathroom continue the illusion of stone from the whirlpool tub surround to the ceiling. *Courtesy of Buddy Rhodes Studio, Inc.*

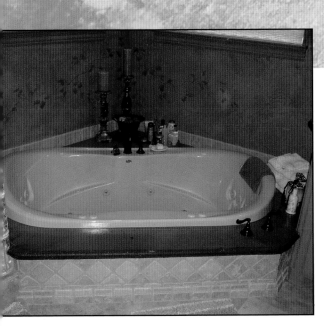

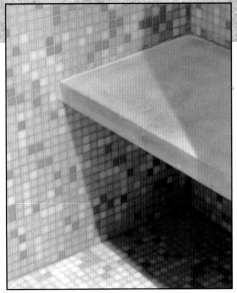

◀Concrete was used to create a platform for this deep soaking tub. *Courtesy of The Ultimate Edge, Inc.*

◀A shower bench coordinates with the tile effect in concrete. *Courtesy of FormWorks*

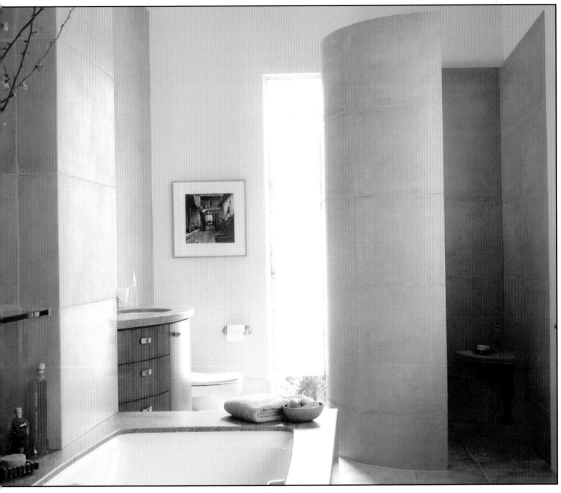

◀A curved wall creates a shower stall separate from the rest of the bathroom. *Courtesy of Buddy Rhodes Studio, Inc.*

In a room where water is of the utmost importance, the surrounding structure needs to be watertight and water resistant. Traditional tile has served this function, protecting the wood and plaster architecture from the potentially harmful side effects of sinks, toilets, tubs, and showers. Concrete steps in with so much more to choose from, design-wise. After all, colorful bathroom rugs are often selected to brighten a room. Why not start with a floor that's colorful and exciting and forego the need to accent? Again, color possibilities are endless in concrete.

▲ The English red stain used on the floor of this small bathroom adds richness and drama. *Courtesy of Kemiko Concrete Stains*
▶ In place of the decorative throw rugs often found in bathrooms, an intricate design has been etched into the floor. *Courtesy of Engrave-A-Crete™*

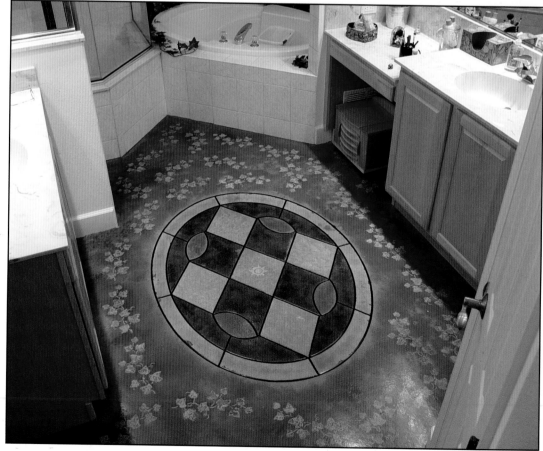

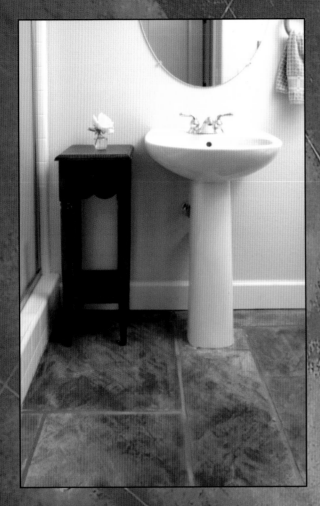

An earth-tone flagstone pattern emphasizes the white porcelain sink and cream-colored walls. *Courtesy of Bomanite Corp.*

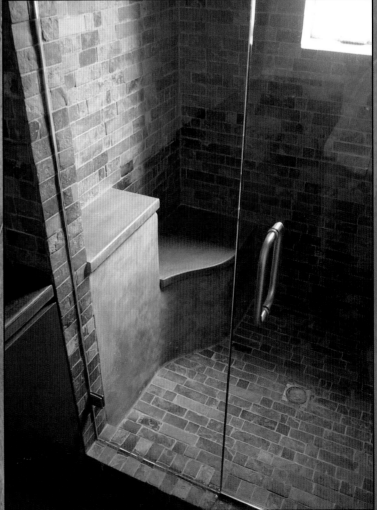

▶A bench and shelf were crafted in concrete for this handsome shower stall. *Courtesy of DeWulf Concrete*

# Beyond

Placed or cast horizontally or vertically, integral to the architecture, or as separate as a tabletop, concrete's possibilities are endless. The following images take you through more rooms, and leave you with a sampling of the realm of possibilities. Enjoy!

▶Decorative concrete was stained with warm, earthy tones to anchor this room with indoor pool. *Courtesy of Kemiko Concrete Stains*

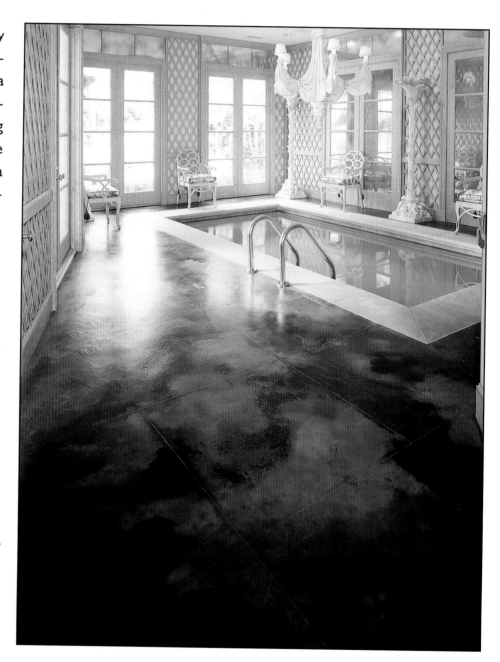

◀ Aqua creates an inviting parking place.
*Courtesy of Artscapes*

▼ A fantastic floral motif graces a garage floor.
*Courtesy of Engrave-A-Crete*™

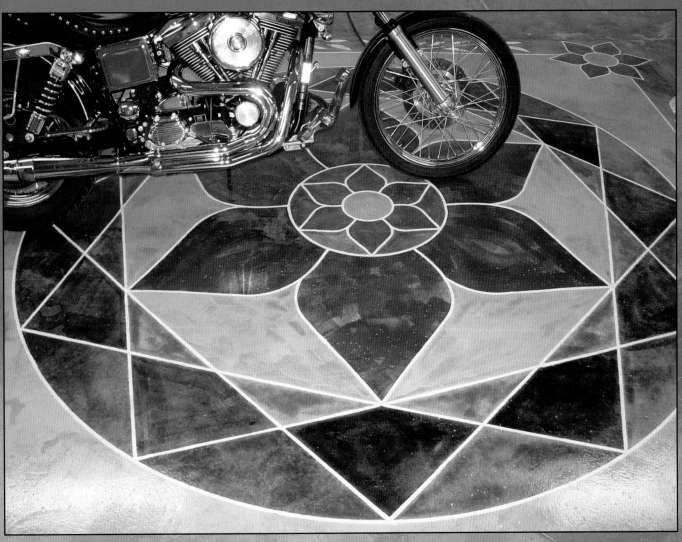

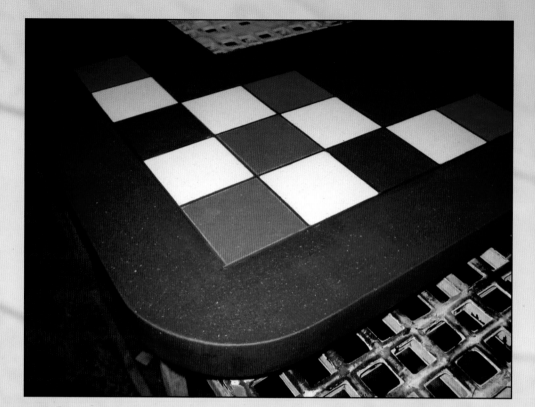

▶A colorful interplay of squares, etched and grouted, creates the look of inset tile. *Courtesy of FormWorks*

▶Concrete combines with polished steel to make a desk that is both artistic and functional. *Courtesy of DeWulf Concrete.*

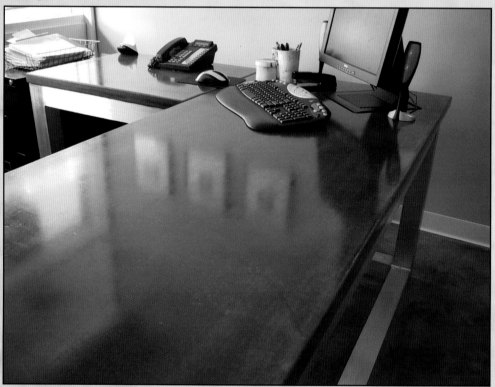

Photography by Lisa Thomas

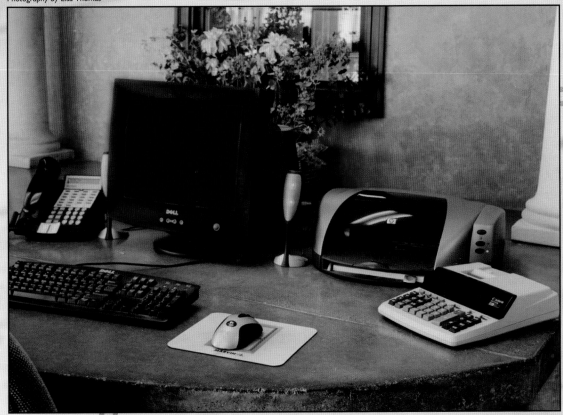

◄Concrete lends itself perfectly to curved lines and substantial heft. *Courtesy of Arends Construction & Design Inc.*

◀Decorative concrete was the mate-rial of choice for someone who wanted to set himself apart. In addition to two textures on the surface, the cast, funnel-shaped base has been finished with a marbleized effect. *Courtesy of Verlennich Masonry & Concrete*

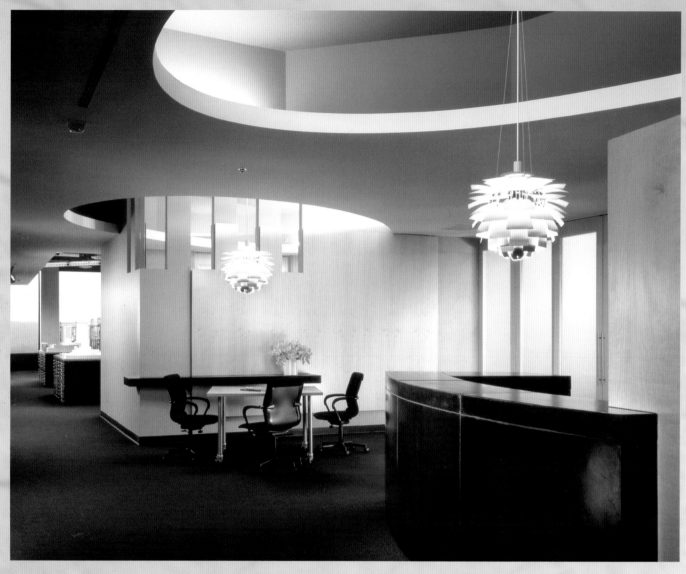

A black reception desk with curved front panels adds dark contrast to a light lobby.
*Courtesy of Buddy Rhodes Studio, Inc.*

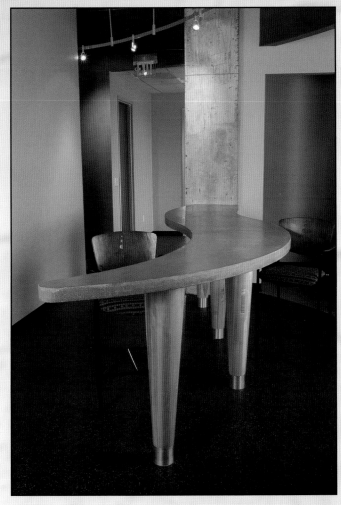

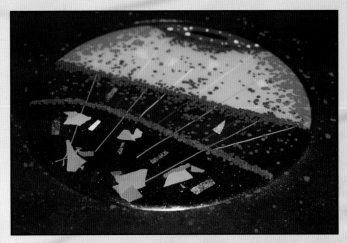

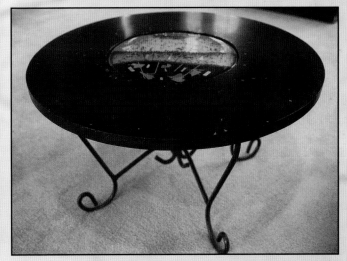

◄A swoosh of concrete forms an ultra contemporary desk surface, supported by stylish metal columns. *Courtesy of Meld USA, Inc.*

►This whimsical table was created to support and set off a hand-made fused glass platter created by artist Jeff Brooks. Pieces of the same glass used in the platter were incorporated into the concrete. *Courtesy of FormWorks*

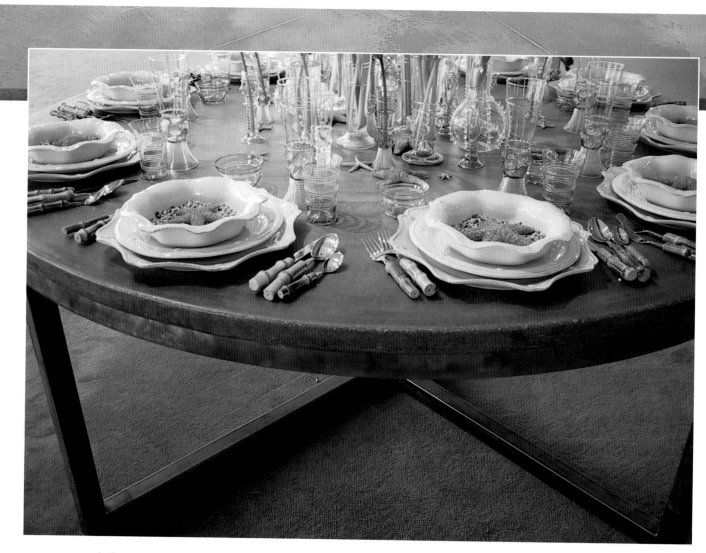

▲Concrete is not just for countertops, it can be used to make furniture like this table.
*Courtesy of DeWulf Concrete*

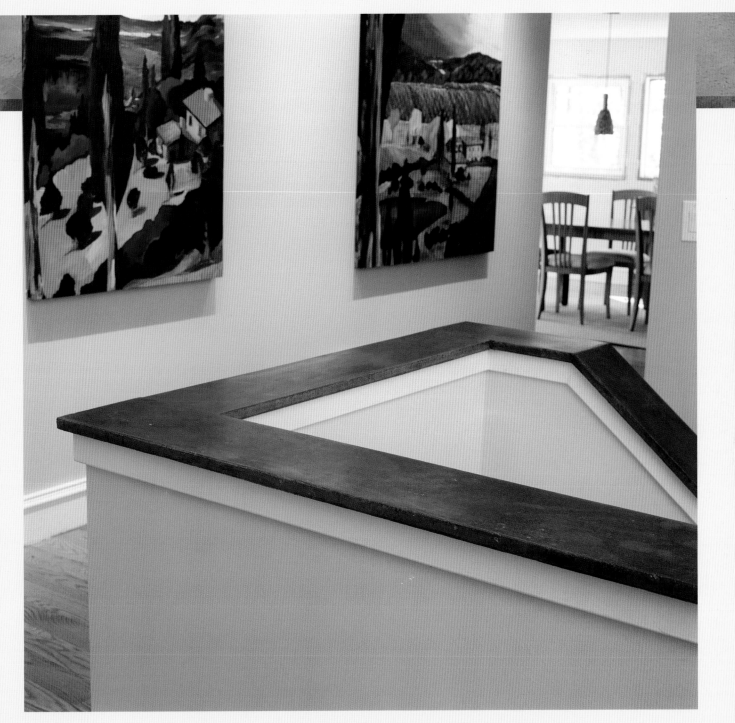

▲This banister and handrail will be exposed to years of hands-on use.
*Courtesy of J. Aaron Cast Stone*

▶ Here, a concrete veneer has been applied to an existing wall. *Courtesy of Yoder & Sons LLC*

▼ Rest assured in a fireproof concrete bed. Asian style, this bed surround allows for firm seating. *Courtesy of DeWulf Concrete*

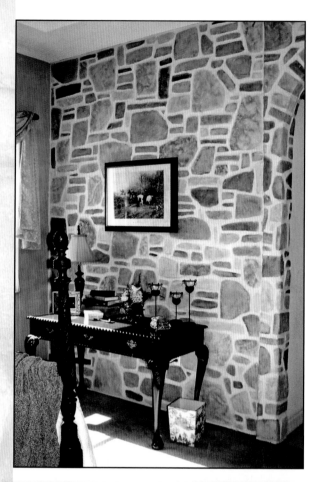

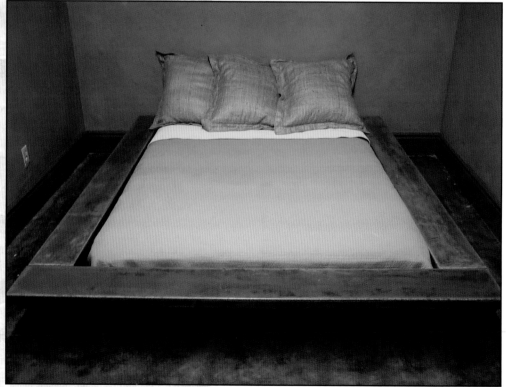

# Resources

The following represent installers as well as product manufacturers for the projects pictured in this book:

Accu Flow Floors
Barrington, Illinois
847-304-9523
www.accuflowfloors.com

Action Concrete Services
Canton, Michigan
734-397-9200
www.actionconcreteservices.com

Advanced Surfacing
Austin, Texas
800-641-4947

ARENDS Construction
San Carlos, California
650-593-5313
www.trexpert.com

Artscapes
Albuquerque, New Mexico
505-452-2500
www.artscapesconcrete.com

BonTool Co.
Gibsonia, Pennsylvania
724-443-7090
www.bontool.com

Bomanite Corp.
Madera, California
599-673-2411
www.bomanite.com

Buddy Rhodes Studio, Inc.
San Francisco, California
415-641-8070
www.buddyrhodes.com

Classic Concrete
Richfield, Minnesota
612-243-0573
www.classic-concrete.com

Classic Concrete Design
Durham, North Carolina
919-272-2072
www.ccd-nc.com

The Concrete Colorist
Benicia, California
510-913-1991
www.theconcretecolorist.com

Concrete Concepts Inc.
Hackensack, New Jersey
201-488-2968
www.concreteconcepts.com

Concrete Creations
Tulsa, Oklahoma
918-812-8829/405-912-2311
www.acidstainedconcrete.com

DeWulf Concrete
Los Angeles, California
310-558-8325
www.dwconcrete.com

The Concrete Impressionist
Brooklyn, New York
718-677-1298
www.concreteimpressionist.com

Engrave-A-Crete™
Bradenton, Florida
800-884-2114
www.engrave-a-crete.com

Concrete Tops of Winter Park, LLC
Winter Park, Florida
407-677-7373
www.concretetops.com

Flex-c-Ment; Yoder & Sons LLC
Greer, South Carolina
864-877-3111
www.flex-c-ment.com

Concrete-FX
Agoura Hills, California
818-865-1198
www.concretefx.net

FormWorks
Raleigh, North Carolina
919-656-2598
www.concretecountertops.biz

Creative Concrete
Staining & Scoring, LLC
Hazel Green, Alabama
888-397-9706
www.concretefloorart.com

Homecrete Concrete Surfaces
Lexington, Kentucky
859-621-7897
www.homecrete.com

DCI
Webb City, Missouri
866-332-7383
www.decrete.com

Images in Concrete
El Dorado, Arizona
870-862-5633
www.imagesinconcrete.com

J. Aaron Cast Stone
Atlanta, Georgia
404-454-3221
www.jaaroncaststone.com

Kemiko Concrete Stains
Leonard, Texas
903-587-3708
www.kemiko.com

Meld USA, Inc.;
Extremeconcrete® Counters
Raleigh, NC 27616
919-790-1749
www.meldusa.com

Ministry Concrete
El Cajon, California
619-579-0347
www.ministryconcrete.com

Skookum Floors USA
Seattle, Washington
206-405-3700
www.skookum.com

Sonoma Cast Stone
Sonoma, California
888-807-4234
www.sonomastone.com

Specialty Concrete Designs
Poplarville, Mississippi
601-795-9249
www.specialtyconcretedesigns.com

Sullivan Concrete
Costa Mesa, California
800-447-8559
www.Sullivanconcrete.com

The Ultimate Edge, Inc.
Rowlett, Texas
214-607-4004
www.ultimateedgeconcrete.com

Verlennich Masonry & Concrete
Staples, Minnesota
218-894-0074
www.stampedinstone.com

XcelDeck
Phoenix, Arizona
800-644-9131
www.xceldeck.com

Xtreme Concrete
Soquel, California
831-462-2334
www.xtremeconcrete.com

**Built to Last: A Showcase of Concrete Homes**. Tina Skinner. If you're thinking about building a new home, you'll want to start here. This introduction to insulating concrete form (ICF) construction will open your eyes to the future. ICF construction combines man's best building materials - concrete and steel, with high-tech insulation - bringing them together in simple forms a small child can lift. Anyone with basic carpentry experience can assemble them. Concrete construction offers rock-solid homes that can withstand hurricane-force winds, drastically cut energy costs, and provide unbeatable air and sound quality, in buildings as beautiful as the designer's imagination. Tour 15 gorgeous showcase homes, complete with floor plans, which demonstrate the endless design possibilities available with concrete. Architects, contractors, and homeowners share their experiences designing, building, and living in the best-built homes available today.

Size: 8 1/2" x 11"          226 color photos          144 pp.
ISBN: 0-7643-1617-6          hard cover          $29.95

**Decorator Show Houses: Tour 250 Designer Rooms**. Tina Skinner, Melissa Cardona, & Nancy Ottino. Welcome to the Ultimate Decorator Event! For the price of admission to one show house and a modest luncheon, you'll get to tour 50 different show houses and over 250 spectacular rooms, where designers have pulled out all the stops to showcase their very best. Some of the most extraordinary work in interior design today is presented in 513 stunning color photographs. You'll see rooms saturated in glorious paint, windows dressed in the finest draperies, surfaces transformed with faux finishes, and furniture swathed in luxurious fabrics. Beginning the tour in foyers and hallways that leave lasting first impressions, you'll continue through glorious living rooms and family rooms that you'll never want to leave. Make your way through amazing libraries and home offices, dining rooms, kitchens, sunrooms, bedrooms, and bathrooms. You'll also get a chance to see innovative design ideas for media rooms, wine cellars, loft spaces, and bonus rooms. In this book you will find breathtaking and exciting designs that will inspire and amaze you, in addition to a list of extraordinary interior designers and annual show house events.

Size: 8 1/2" x 11"          512 color photos          224 pp.
ISBN: 0-7643-2051-3          hard cover          $44.95

**Big Book of Kitchen Design Ideas**. Tina Skinner. More than 300 big, full-color photographs of stunning kitchens provide an encyclopedic resource of design ideas for homeowners, designers, and contractors. The kitchen designs presented here include award winning designs and fancy product showcases designed for many of the nation's leading manufacturers of cabinetry, countertops, windows, appliances, and floors. Many styles of kitchens are covered, from contemporary and country, to classic European looks, early American, retro, and art deco designs. Special needs are addressed for elderly and handicapped users, as well as design issues faced by families with young children. There are designs for people who entertain frequently, and for those who need the kitchen to serve every purpose—from home office to dining room, to laundry room.

The book is designed as a reference library for the do-it-yourselfer, or as a bank of illustrations to share with a designer or contractor when seeking the right look for your old or new home. A reference guide at the back of the book lists manufacturers and designers ready and eager to help you on your way to creating the perfect heart for your home.

Size: 8 1/2" x 11"          321 color photos          144 pp.
ISBN: 0-7643-0672-3          soft cover          $24.95

**Great Kitchen Designs: A Visual Feast of Ideas and Resources**. Tina Skinner. Here is a collection of 370 gorgeous color photos to pour over and ponder: images to inspire dreams. Full-color pictures of hundreds of beautiful kitchens will help you sort out the details and create your own unique cooking/dining/entertaining environment. All the elements of beautiful kitchens—flooring, cabinetry, windows, walls, lighting, appliances, surrounds, backsplashes and more—are pictured and discussed. Individual chapters will help you find the right look, exploring current trends from exotic to country, formal to feminine, antique to modern. Imaginative solutions for showing off collections are explored, as well as ways to open up the kitchen to wonderful outside views. There are lots of ideas for creating gathering places for family and guests alike into the hearth of the home. A special chapter on the small kitchen illustrates solutions for homes with limited space, and a resource guide at the back of the book will point you toward award-winning designers and top-notch manufacturers. This is an invaluable resource for anyone planning to remodel an old kitchen or build a new one and a great reference book and sales tool for any kitchen design professional.

| Size: 8 1/2" x 11" | 370 color photos | 176 pp. |
| ISBN: 0-7643-1211-1 | soft cover | $29.95 |

**Fire Spaces: Design Inspirations for Fireplaces and Stoves**. Tina Skinner. Warning: This book will make you want to include a fireplace or stove in almost every room in your home, and the yard too! The beauty, alluring warmth, and technological ease and cleanliness of today's hearth products make having a fire faster, easier, safer, and more enticing than ever. This book illustrates the allure, with more than 400 gorgeous color images. It's easy to find your style, visiting hundreds of homes and experiencing the way that they have incorporated fire spaces into their living spaces.
There has never been a book like this, with so many wonderful images of fireplaces and stoves. Most are shown within room settings, helping you to envision a fireplace as part of your overall decor. Plus, there's an enormous gallery of close-up images showing fireplace and stove details. You'll have trouble choosing just one!

| Size: 8 1/2" x 11" | 417 color photos | 176 pp. |
| ISBN: 0-7643-1694-X | hard cover | $34.95 |

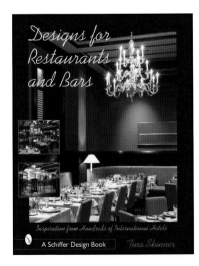

**Designs for Restaurants & Bars: Inspiration from Hundreds of International Hotels**. Tina Skinner. Here is a sumptuous banquet of the hospitality world's finest offerings in places to eat and drink. Tour more than 200 designer and boutique hotels from around the world, along with classics such as The Ritz in London, The Oriental Bangkok, the New York Palace Hotel, and the Hôtel Plaza Athénée in Paris. Top hotel and restaurant design firms from around the world are included, with industry leaders such as David Rockwell, Ian Schrager, Robert DiLeonardo, and Adam Tihany. Plus, there is work by design world icons Karl Lagerfeld, Pierre Court, Patrick Jouin, and Philippe Starck. The visual banquet includes classic European designs dripping in decorative molding and custom paneling, gold leaf and crystal chandeliers. There are starkly modern designs, fashionable Asian Fusion and eclectic settings, and tropical paradises, as well as playful and erotic designs. A resource guide provides contact information for design and architectural firms, as well as the beautiful establishments shown. This is an inspiring book for anyone planning or designing a place of hospitality and consumption.

| Size: 8 1/2" x 11" | 256 color photos | 176 pp. |
| ISBN: 0-7643-1752-0 | soft cover | $39.95 |

Schiffer books may be ordered from your local bookstore, or they may be ordered directly from the publisher by writing to:
Schiffer Publishing, Ltd.
4880 Lower Valley Rd
Atglen PA 19310
(610) 593-1777; Fax (610) 593-2002
E-mail: Info@schifferbooks.com

Please visit our web site catalog at *www.schifferbooks.com* or write for a free catalog.
Please include $3.95 for shipping and handling for the first two books and $1.00 for each additional book.
Free shipping for orders $100 or more.

Printed in China

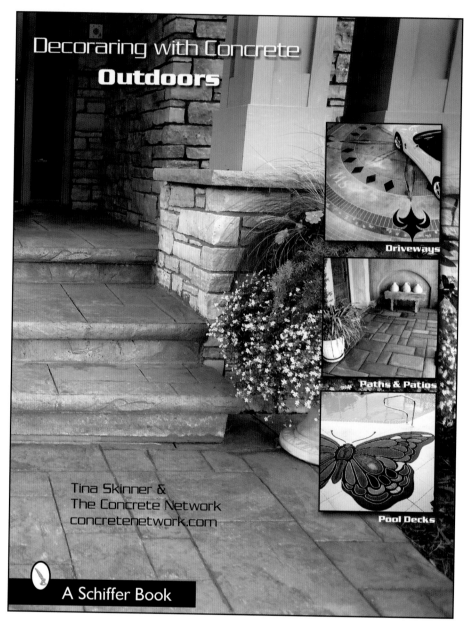

**Decorating with Concrete Outdoors: Paths and Patios, Pool Decks and More.** Tina Skinner & The Concrete Network. Today's landscapers can offer consumers the rich look of stone, brickwork, and worn cobble paving all in decorative concrete. Prices are very competitive, and maintenance, safety, and durability are often vastly improved when traditional materials are duplicated in concrete. Beyond the traditional looks, today's technology is enabling craftsmen and artists to experiment and explore the ever-expanding uses for concrete. The variety of new permanent colors for concrete is infinite and the textures limited only by imagination.

This book takes you on a visual journey through ambitious as well as obvious applications for concrete in the home, from patios, driveways, and walkways, to elaborate outdoor kitchens and pool environments. More than 200 photographs highlight artistry in concrete and inspire craftsmen and do-it-yourselfers to create rich textures and colorful murals on porches, driveways, patios, and more.

Size: 8-1/2" x 11"    Over 200 color photos    128pp.
ISBN: 0-7643-2199-4    soft cover    $19.95